書，翻頁，前者的記憶仍在；合起來，過程的回憶，抹滅不掉

Flipping through a book, memories remain.

Closing it, memories of making it are unerasable.

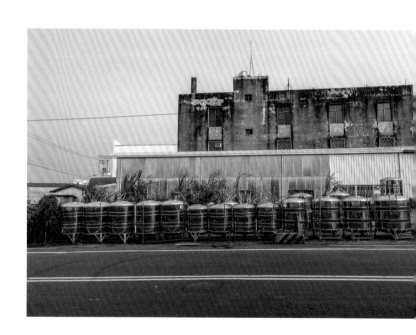

次　CONTENTS

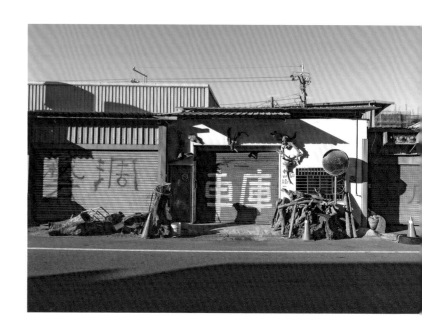

品資訊

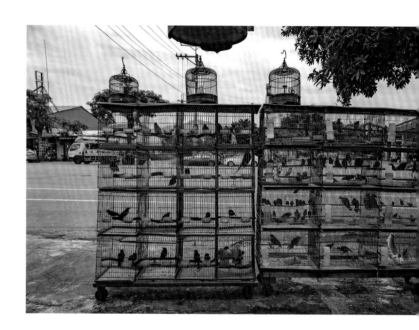

在疫情中創作

病毒持續變種宅在家，多少讓人體悟了，減少（任何）病毒擴散的最佳方式就是減少群聚。

後疫情社會可真會變成少少人的活動現象？疫居對我們的生活信念可有影響？

說：相較以往，歐美今年器官移植個案數減少了，只因為潛在的捐贈者，疫居期間食用了較多的垃圾食物，器官捐贈的品質不佳；而環保人士更憂心的是：大量外送和網購所產生的垃圾，要環保觀念如何扭轉劣勢？

走出疫情威脅的國家，則驚訝的發現：早先各式各樣救濟金的後援策略，多少導致了零售商面臨應聘工人的現象；千禧世代，重視在有限的生命裡發揮自我的最大價值，回絕過往朝九晚五的工作型態成為趨勢；於救濟金的發放需求，豪宅、高檔電動車的市場卻異常熱絡。

家，媒體成了訊息的主宰者，它讓我看到的不是全島一命或全球一體的大同曙光，而是民主和極權國家的形態衝突，國與國之間的政治不信任；它讓我看到戴口罩與施打疫苗的紛爭，成了政客的操弄武器；它更感受到，即使有「黑人的命也是命」的先難，仍無法改變膚色較深的人對種族主義的害怕。

人椎心的是，在全球性疫情封、解、鎖、開的循環中，網路成了有心者的操弄槍砲，它瞄準的不是當下（可來）的敵人「病毒」，而是人與人之間的信賴感與良善的信念。和眾人生命相關的訊息持續讓人困惑不已，譴責那些使用它的壞人嗎？難！如果他們可以被看清楚，就無法贏得這個頭銜；再說，網路工具的必要性，是「網路好人」最鄉愿的藉口？正、反雙方偽裝的拉鋸與對話，不減虛擬空間裡詐欺、惑眾妖言，人性本故事一則接著一則；大眾唯恐成受害者的憂懼，一層裹一層；網路訊息從疫情到政治，永遠都是真假難辨。

的目光疲憊不堪了！心，想要鴕鳥的回到沒有網路之前的世代；文化、知識就算笨拙了一點；經濟差了一，又有何妨？只要可以免去點政治競賽、鬥爭的神經兮兮！

步的現代勢力和反動勢力無止境的較量下，「救世主」在哪裡？「避風港」又在哪裡？

──我的 FB 貼文、我的創作──《招・術》！

1 的新作《招‧術》，不敢奢望大聲嚷嚷疫情期間所見、所思的片面，但盼藉由媒介的意念轉換，舒展
□的困頓、自建一點正能量。因此，《招‧術》的台灣照像，有意讓商業活動中的人形和販賣情節缺席，
□靜的傳播方式，邀約觀者更多想像和情感的參與。

□‧術》的影像，從沒有行銷包裝的「實物展售」開始，再進入公共場域中，沒有「實物展售」僅有各
□招引人的看板訊息，以此展現──臺式招呼客人的直率。

□‧術》影像所並置的短文，則是有感於網路文化長期以來的亂象，在疫情大流行期間所帶出更多的焦
□悲情，於是，從影像拍攝記憶的斷裂點出發，注入新的文字發想；意圖藉由：生活中的真影像、偽遊記，
□、舊、真、假的語言、故事和情感，來對應當今網路訊息真假難分的困境。簡單的說：

溫馨的「臺式常民看板」──調侃網路上誇張不實的銷售誘惑；

直敘、類訊息的文字──省思過度包裝的網路行銷；

擬真的小說──影射網路訊息真假難分的現況。

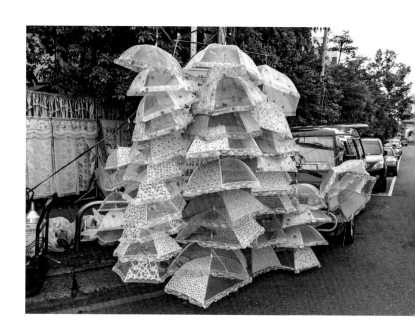

‧術》的影文並置結構中，有單張跨頁的影像，也有上下或左右並置的「近似時空」影像，意圖藉類
像間的流動想像，凸顯網路傳播過程中，觀者多不花心思、匆匆一瞥的心態，並進一步探討下列相關
題：

對象眷戀的情感

者要從本質性關懷的對象中轉移，不是那麼容易。《招‧術》並置既連續、又間斷的影像，不全是拍
拿捏不定、情緒徬徨的寫照，而是表徵：拍照過程，作者很容易因為高度的關注對象，產生情不自禁
戀反應；換句話說，創作情感方面，如同現實中熱戀的男女，見面之後捨不得分手、讀你千遍也不厭
因此，在重複衝動的能量下，對同一個對象進行了連續的照像。

思，人在照像中的主體性

表現畫家可以藉由顯著的筆觸，展現自身介入在繪製中的主體性，反觀攝影家頂多就只能用稍長時間
光，刻意搖晃機身產生晃動的影像來展現自身介入的主體性。或許就是因為拍照身體的限制，讓不打
攝對象的「拍攝者透明化」理念，被廣泛的採納。但是，《招‧術》對於人在照像中的主體性議題，
試以並置的「相類似影像」來表徵——人在拍攝現場，努力的想要在當下做出決定的糾結實情，甚至
聲的提醒觀眾：

「你看這裡，你再看一次這裡！」——影像中，快門與快門之間相隔的長度

「看到了沒？你到底看到了沒？」——影像中，現實時間的深度

既連續、又間斷，影像紀錄的破口

續、又間斷的影像思緒，來自於觀察近代數位影像軟體，如何將短暫幾秒鐘的連續動態影像，造成
動合一，並提供攝影者從眾擇一的方便性。由此反思，拍照之後那些沒有被選上的影像最後命運如
被判永久刪除？不經意遺忘、流失後，在不同情境下，再被重新找出來成為作品？果真如此，所謂
「影像紀錄」就沒有永遠死亡這件事！有感於此，《招‧術》並置的影像，

　　　　提醒：創作活動中，作者無法避免的主觀選擇
　　　　凸顯：影像還原現場，在資訊上的斷層與落差
　　　　強調：人在認知的過程中，總是不連續，甚少全程參與的現實
　　　　體悟：靜態影像從未被完全固定下來的哲思

招‧術》在藝術書本的呈現形式上，並不閃躲裝訂線對於跨頁圖文的干擾，反而刻意讓它穿越每一件
的作品，強行將內文區隔成為左邊、右面或上端、下緣的獨立空間，使讀者得透過潛意識的認知與
先前的經驗，將已經被區隔的訊息加以併組。《招‧術》希望藉由跨頁文化和下凹、微暗的裝訂線
，能碰撞讀者對於書本閱讀的慣性，並對書本裝訂線所造成跨頁文字、圖像分分合合的現象，提出
的藝術思維。

　　　　大圖，跨頁，眼珠，悠閒，讀半邊，微弧，書丘，滑溜，下陷，光暗，
　　　　裝訂線，爬升，細讀，微弧，另半邊，影像，立體，文字，空間。

　　　書，翻頁，前者的記憶仍在；合起來，過程的回憶，抹滅不掉
　　　　　　　　　　　　　　　　　　　—— 游本寬 2021‧仲夏

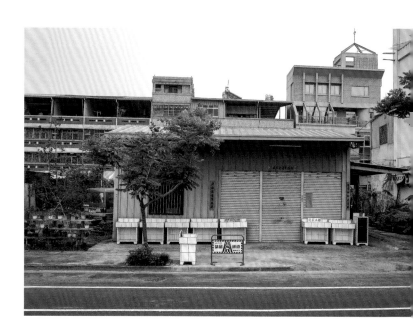

eface

Work During the Pandemic

the virus continues to mutate and we stay at home, we've come to realize that the best way to reduce the ead of (any) virus is to limit gatherings. However, will post-pandemic life really become a phenomenon of er interactions? Will the lifestyle we have grown used to during the pandemic have an impact on our personal ologies?

this country begins to emerge from the pandemic, I was surprised to see that the economic relief measures vided by the government) have resulted in hiring trouble for employers. Millennials attach great importance ard maximizing the best value in their limited lives. Rejecting the traditional 9-5 work cycle has become a d. On one hand, the demand for relief payments/bailouts remains, on the other, the market for luxury homes high-end electric vehicles continues to surge.

ile staying at home, the media has become the master of information. What I have come to realize is that this ot the beginning of a unification, such as that of an entire island/community sharing the same fate, or the entire e becoming one. Rather, it is the dawn of an ideological conflict between democratic and totalitarian regimes, political distrust between nations. It has shown me that mask wearing and vaccines have become weapons ded by politicians. The media also made me feel that despite the tragedies that ignited the suppressed pain of ck Lives Matter," it cannot change the fear some harbor toward those with darker skin.

at is more despairing is that in this seemingly never-ending pandemic cycle of opening and closing, the rnet has become a gun wielded by the ambitions/those with ulterior motives. The muzzle of this gun is not ted at our current (and future) enemy, the virus, but at the bonds and trust between people. Information with relevance to our lives continues to be difficult and confusing. Should "bad people " who exploit this fact on Internet be criticized/censored? It's hard to say one way or the other. It's not easy to see who these "bad ple ' are when they are hidden and live among us. Besides, wouldn't such criticism from the "good people" advocate for a free and open internet be hypocritical? This seesawing dialogue between "good" and "bad" ple, continued fraud/disinformation, deceptive rumor spreading… all symbolize the endless cycle of the evil inflict upon each other. One after another, victims fall prey to the public's fear-mongering, and it is hard to inguish between truth and lies on the Internet, in all subject matters from the pandemic to politics.

exhausted lifeless eyes cannot bear it! My heart wants me to bury my head in the sand and return to the -Internet era. Even if the culture and knowledge was a bit clumsy, the economy a bit worse, what's the big l-who cares? So long as you can avoid the political competition and neurotic fighting! In the endless contest ween progressive and regressive forces, where is the "Savior?" Where is this "Safe Haven?"

and check out my Facebook post and artwork… *"Welcome: The Art of Invitation"*

Welcome: The Art of Invitation is my 2021 work that I can only humbly claim to be fragments I've observed during the pandemic. I am hoping to build up some positive energy by transforming thoughts and ease my unhappiness. In the images of *Welcome: The Art of Invitation*, real characters and economic activities are absent in order to stimulate greater imagination and emotional involvement from people through restrained communication.

Images in *Welcome: The Art of Invitation* represent public goods and services for sale devoid of sophisticated marketing strategies. Without particularly attractive designs, these messages posted by a variety of businesses demonstrate a straightforward attitude among Taiwanese greetings.

Stories accompanying each image in *Welcome: The Art of Invitation* are inspired by the long-term phenomenon of chaos in digital media as well as the anxiety and sentiments people feel during the pandemic. At that point where the memory embodied in a photo breaks away, I add my own fictional narratives as an effort to respond to messages found online in which fiction and reality are indistinguishable. I mix real images and fake journals with old or new stories, and true or made-up words. In short, they are:

The homely Taiwanese style advertising signs very dear to the public are contrary to the untrue but very tempting online marketing strategies.

Plain and direct messages make us rethink the exaggerated character of online promotion.

Very authentic fiction refers to online messages that there is no way to confirm the authenticity of.

In *Welcome: The Art of Invitation*, images and texts are arranged side by side. Some single photos spread across two pages, some are two photos arranged up and down or left and right on one page. By making use of the flowing imagination from image to image, I mimic the fast online browsing in this era in which information is never really focused upon clearly. Further issues I explore are:

Sentimental attachment to the subject
Welcome: The Art of Invitation juxtaposes continuous and discontinuous images and symbols. During the time spent taking photos, I unwittingly developed sentimental attachments to the subjects I was shooting.

My subjectivity in photography
While abstract expressionist artists show subjectivity through an intense physicality of brush strokes in the paintings, photographers try to remain unseen, objective, and unobtrusive. Fundamental to the act of photography is having a physical presence on scene where creation of the photograph occurs. In *Welcome: The Art of Invitation*, I juxtapose comparable images together on a two-page spread to call attention to my subjective thinking and to reveal the struggle in making decisions at the moment of photographing.

ntinuity and discontinuity, the cracks of filming and recording

thoughts about images that are both continuous and discontinuous came from my observation of digital ige software recently developed. They produce static or dynamic images by taking continuous photos in a seconds and conveniently provide photographers the ability to select those they want. So what happens to se photos not selected? Are they to be deleted for good? Or, after being forgotten for sometime, they might be iscovered and presented one day under certain conditions? If it is true, nothing would really end in filming and ording. Thus, *Welcome: The Art of Invitation* addresses several points:

Reminding myself that I can't avoid subjective decisions for my work.
Outlining the discrepancy and gaps between the scenes and the information.
Emphasizing that one seldom is present all the time during the discontinuous formation of recognition.
Realizing that static images are never fixed.

e design of *Welcome: The Art of Invitation*, an art book publication, doesn't dodge or avoid the limitations and erference from a book's central binding, or gutter. Rather, this book embraces and features several two-page eads and text is forcibly pushed into the margins on the left, right, top and bottom. Such a layout, flowing ween two pages and divided by the center, suggests readers incorporate separate messages by subconscious ognition and prior personal experiences. The dark edges of images and text that intentionally disappear into book's gutter challenge one's customary reading pattern and behavior. This design highlights an alternative I challenging approach to the book's format through the use of two-page spreads, disconnected text, embrace he central gutter, and edges of images that sink into darkness.

ge pictures, images across pages, eyeballs, relaxation, reading half side, slight curve, book ridge, sliding, ken, dim, gutters, ascending, reading carefully, slight curves, another half, images, 3-dimensional, words, ces.

Flipping through a book, memories remain.
Closing it, memories of making it are unerasable.

Yu
ust 2021

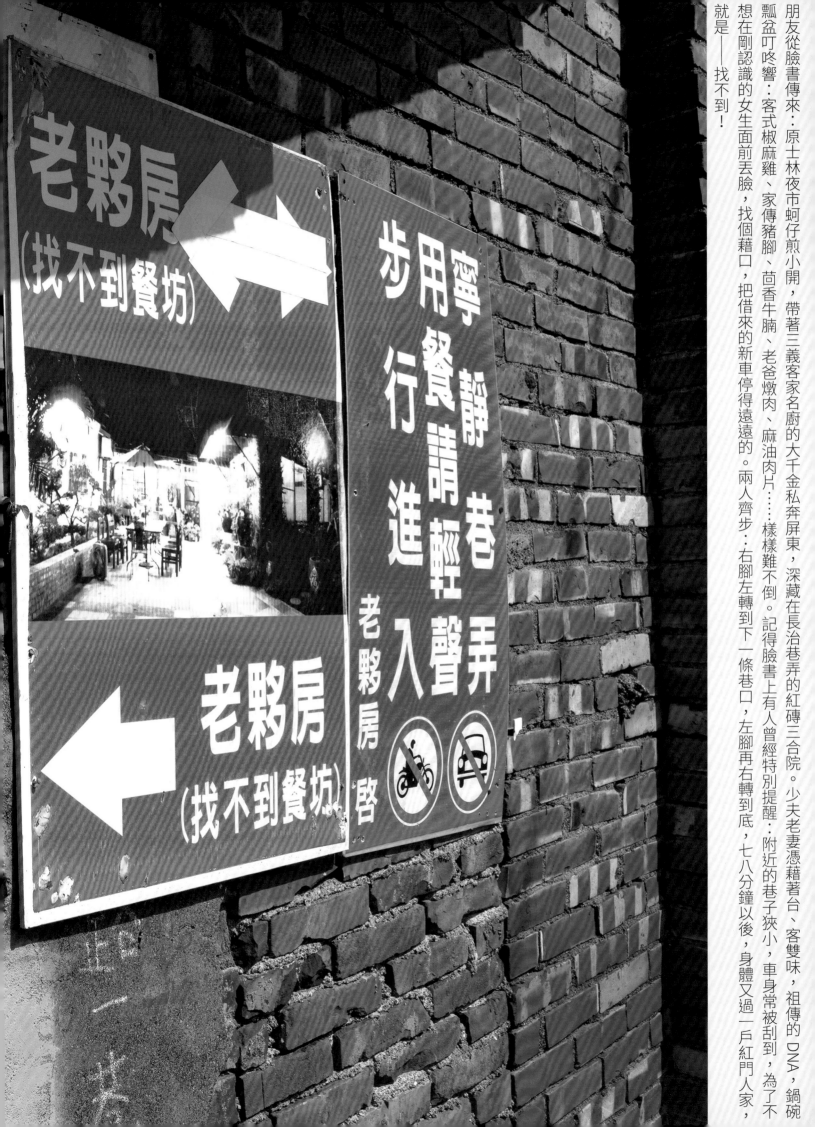

老夥房（找不到餐坊）

用寧靜巷弄
步餐請輕聲
行進入

老夥房 啓

老夥房（找不到餐坊）

朋友從臉書傳來：原士林夜市蚵仔煎小開，帶著三義客家名廚的大千金私奔屏東，深藏在長治巷弄的紅磚三合院。少夫老妻憑藉著台、客雙味，祖傳的DNA，鍋碗瓢盆叮咚響：客式椒麻雞、家傳豬腳、茴香牛腩、老爸燉肉、麻油肉片……樣樣難不到。記得臉書上有人曾經特別提醒：附近的巷子狹小，車身常被刮到，為了不想在剛認識的女生面前丟臉，找個藉口，把借來的新車停得遠遠的。兩人齊步：右腳左轉到下一條巷口，左腳再右轉到底，七八分鐘以後，身體又過一戶紅門人家，就是——找不到！

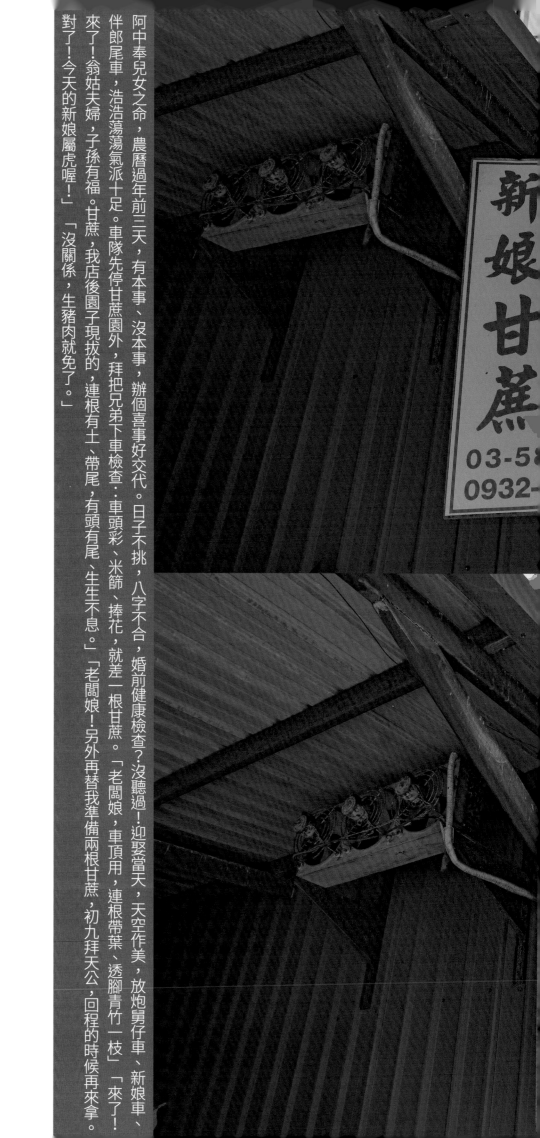

阿中奉兒女之命，農曆過年前三天，有本事、沒本事，辦個喜事好交代。日子不挑，八字不合，婚前健康檢查？沒聽過！迎娶當天，天空作美，放炮舅仔車、新娘車、伴郎尾車，浩浩蕩蕩氣派十足。車隊先停甘蔗園外，拜把兄弟下車檢查：車頭彩、米篩、捧花，就差一根甘蔗。「老闆娘，車頂用，連根帶葉、透腳青竹一枝」「來了！來了！翁姑夫婦，子孫有福。甘蔗，我店後園子現拔的，連根有土、帶尾，有頭有尾，生生不息。」「老闆娘！另外再替我準備兩根甘蔗，初九拜天公，回程的時候再來拿。對了！今天的新娘屬虎喔！」

「沒關係，生豬肉就免了。」

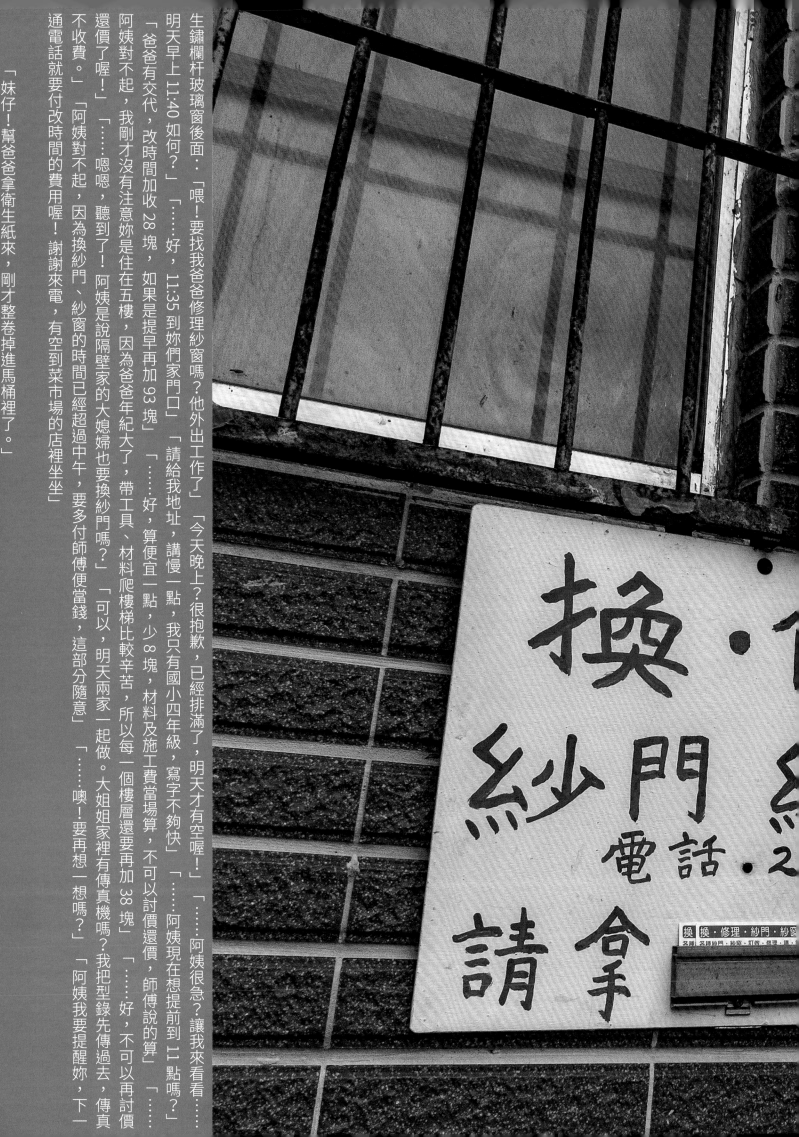

生鏽欄杆玻璃窗後面：「喂！要找我爸爸修理紗窗嗎？他外出工作了」「今天晚上？很抱歉，已經排滿了，明天才有空喔！」「……阿姨很急？讓我來看看……

明天早上11:40如何？」「……好，11:35到妳們家門口」「請給我地址，講慢一點，我只有國小四年級，寫字不夠快」「……阿姨現在想提前到11點嗎？

「爸爸有交代，改時間加收28塊，如果是提早再加93塊」「……好，算便宜一點，少8塊，材料及施工費當場算，不可以討價還價，師傅說的算」「……

阿姨對不起，我剛才沒有注意妳是住在五樓，因為爸爸年紀大了，帶工具、材料爬樓梯比較辛苦，所以每一個樓層還要再加38塊」「……好，不可以再討價

還價了喔！」「……嗯嗯，聽到了！阿姨是說隔壁家的大媳婦也要換紗門嗎？」「可以，明天兩家一起做。大姐姐家裡有傳真機嗎？我把型錄先傳過去，傳真

不收費。」「阿姨對不起，因為換紗門、紗窗的時間已經超過中午，要多付師傅便當錢，這部分隨意」「……噢！要再想一想嗎？」「阿姨我要提醒妳，下一

通電話就要付改時間的費用喔！謝謝來電，有空到菜市場的店裡坐坐」

「妹仔！幫爸爸拿衛生紙來，剛才整卷掉進馬桶裡了。」

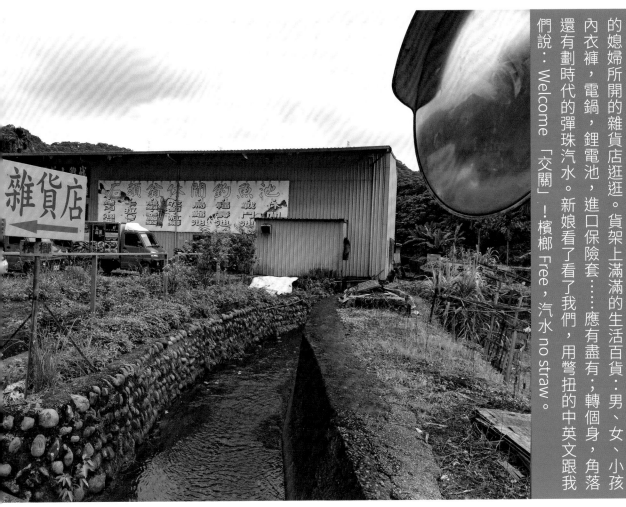

上衣口袋裝著滿滿的績效獎金，開著銀白色的轎車，載全家上山打牙祭。這一陣子山裡常下雨，水氣重，沿途多處的來車反射鏡模糊不清，車速不能快。好不容易過水泥橋，右轉，到了。太太和女兒高高興興的去烤肉，自己就坐在石桌前泡茶，一旁的小男生五音不全唱著卡拉OK。不知什麼原因，土雞城今年不再提供室內釣魚的活動了。好可惜喔！其實，今天原本最大目的就是要釣魚和釣蝦。

飯後，在老闆的拜託下，一家人走進上個禮拜他為來自曼谷剛進門的媳婦所開的雜貨店逛逛。貨架上滿滿的生活百貨：男、女、小孩內衣褲，電鍋，鋰電池，進口保險套⋯⋯應有盡有，轉個身，角落還有劃時代的彈珠汽水。新娘看了看了我們，用彆扭的中英文跟我們說：Welcome「交關」！檳榔 Free，汽水 no straw。

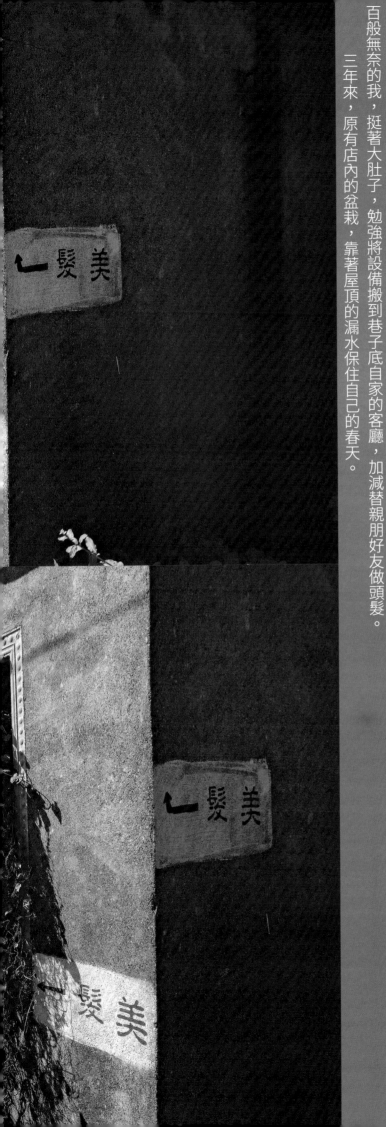

小妹保春秀髮披肩，從小不知道羨煞多少左鄰右舍。畢業後，大姐安排她到溪湖鎮東環路的美髮連鎖店，學習全套的洗、剪、燙、護。老闆娘看上小女生的聰睿，協助她在大突社區開了家只做結構式護髮的專門店。開店前三天，脾氣一向暴躁的保春和我喋喋不休的老公起了大口角，丟下了自己心愛的機車，消失得無影無蹤。

百般無奈的我，挺著大肚子，勉強將設備搬到巷子底自家的客廳，加減替親朋好友做頭髮。

三年來，原有店內的盆栽，靠著屋頂的漏水保住自己的春天。

一命。二運。三風水。

少年讀錯科系？中年選錯行業？壯年做錯投資？老年選錯配偶？來，來，來，巷內算個命，偷窺一下自己的過去與未來。算命，右轉到底，神秘又保密，自備柴油發電，24小時絕不停電。「內巷」算命，趨吉避凶真達人（獨此一家，不要跑錯），專精：紫微斗數（非奇門遁甲）、星座、占卜、塔羅牌，過程4K錄影，法院公證、切結，絕對隱私。

銀樓老闆，隔著玻璃窗看了我和太太許久，走出來對我們說：「我們店內的貨色齊全，價錢絕對公道，不信的話，也可以去找仙仔算算喔！」

南無阿彌陀佛

住在彰化大半輩子，傍晚才第一次造訪花壇白沙坑的文德宮，在洗手間外面聽到一對男女正使用免持聽筒和手機的另一方通話。

中年婦人用優雅「兒化尾」的北京腔說：「張先生，我前夫替我付訂金的時候，你不是保證男生身心健全、有房有車、經濟穩定無負債、無不良嗜好、無犯罪前科、不強制生育嗎？今天，我見到的男人是：和五六個朋友分住一房，有一輛腳踏車，唯一的嗜好是逛銀行，循環使用五張信用卡相互的付帳，然後，每個禮拜都會想帶套子和我行房三次……」

穿著藍白拖的男生搶過手機，用厚重的廣東話向手機大聲咆哮：「付款之前，你不是也跟我保證：身高155公分以上、清秀、單純、身材均勻、有正當職業嗎？現在，站在我面前的女人，剪一個像學生的瀏海，肩膀以下的身材完全同寬，還是五位小孩的專職媽媽！」

手機的另一端用平穩口氣說：「這攏是電腦撿的，完全符合兩位所提的那些條件喔！」

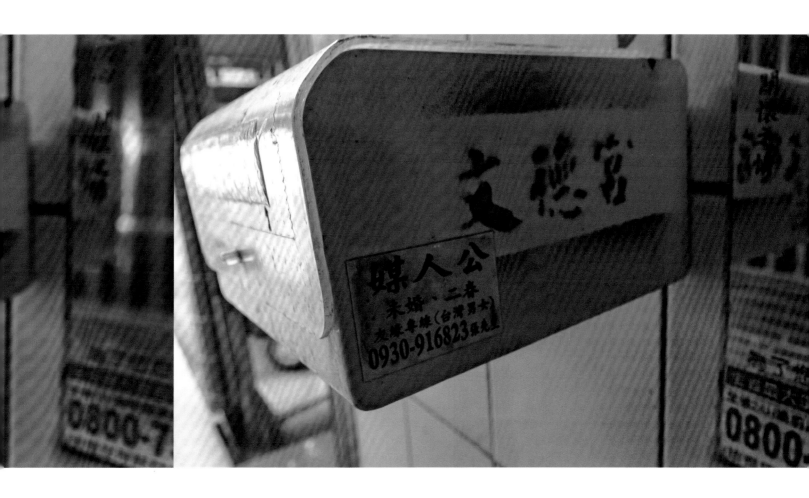

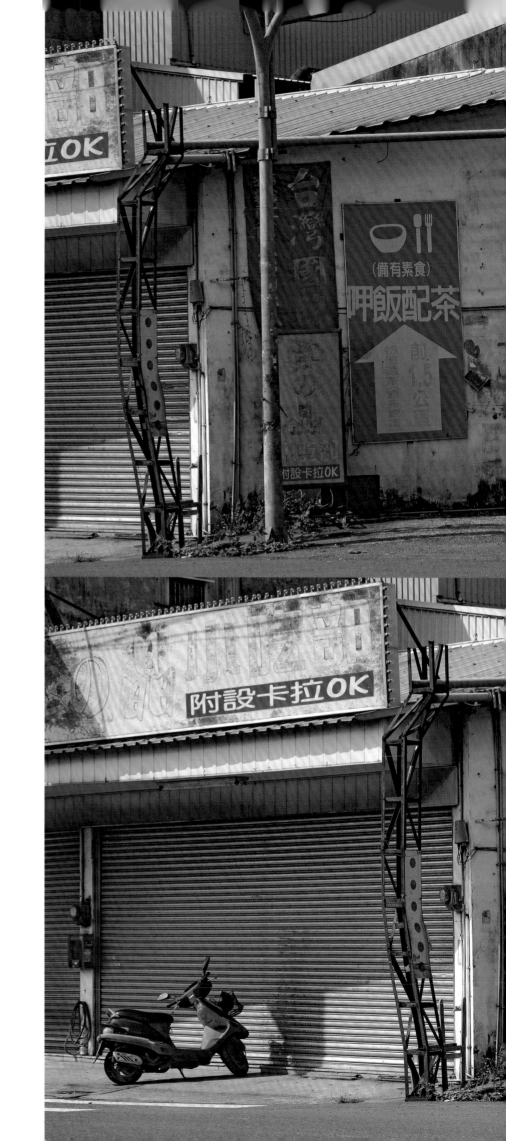

參加台灣國老戰友的聚會，主辦單位一向不供餐，得先找一個地方吃點東西。呷飯配茶？前進1.5公里……呷飯配茶？前進1.5公里，OK啦！不過，醫生才跟我說──邊吃飯邊喝茶，鐵質攝取容易阻礙、茶鹼導致蛋白質變性影響消化，所以牛排不要配濃茶……機車小弟見我面有難色，三步併兩步向前來說：「不必擔心，我用機車載你去！剛剛開幕，吃茶配飯，讚！讚！讚！」邊說邊打開手機 App「白領級豪華泡飯」的菜單：日本進口瓷碗（非粉紅塑膠碗），飯前綠茶，頂級白米飯（越光、中興、西螺、溪洲、上禾壽司任選），鰹魚粉（非廉價的海帶粉），淋上煎茶（玄米茶，烏龍茶二選一），義大利不鏽鋼調羹（非免洗筷）。見我兩腳沒有移動的跡象，機車小弟低聲的說：「這樣好了，吃過飯，我叫老闆送你一張晶晶小吃的優待券，再載你回來這裡，特別為你開門免費唱卡拉OK，如何？」

卡拉OK是茶店仔嗎？😮，不！

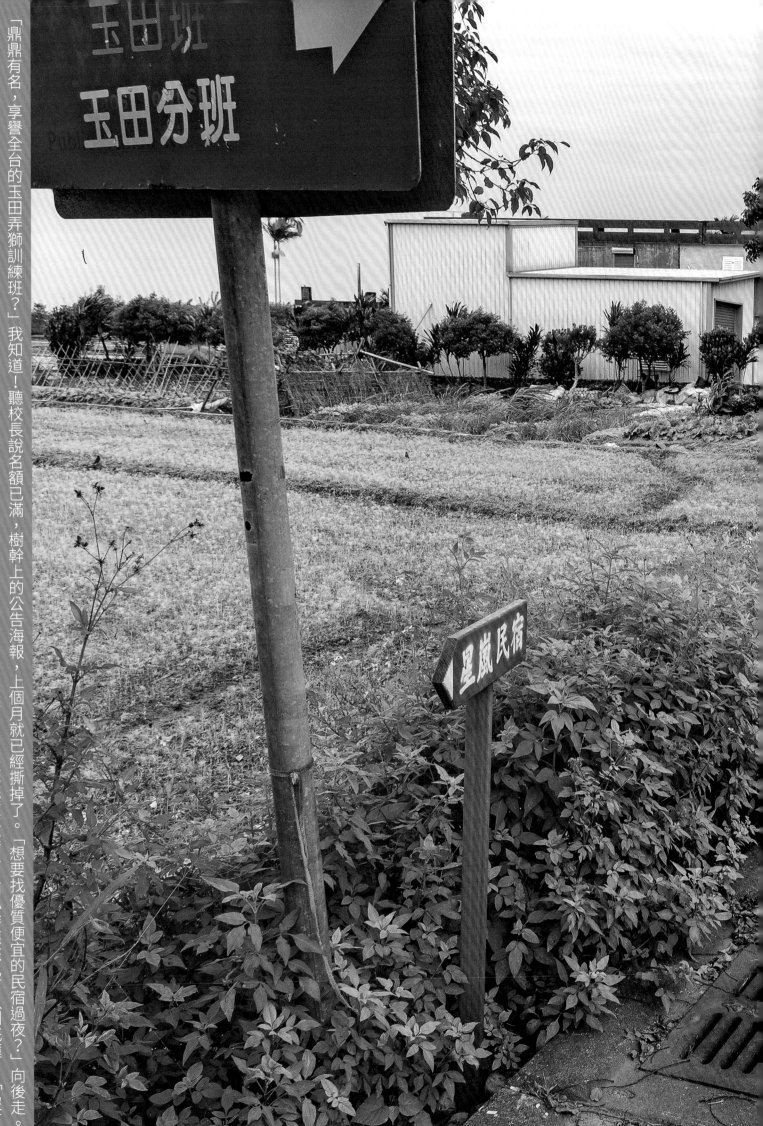

「鼎鼎有名，享譽全台的玉田弄獅訓練班？」我知道！聽校長說名額已滿，樹幹上的公告海報，上個月就已經撕掉了。「想要找優質便宜的民宿過夜？」向後走。「玉田農業專修分班？」過馬路。順著馬路向前開可以到羅東夜市；遠一點的蘇澳有冷泉；油箱裝滿，只要蘇花改不塞車，兩小時應該也可以到花蓮。「沒有一件聽起來有意思？」噢！去對面理髮。

理髪 →

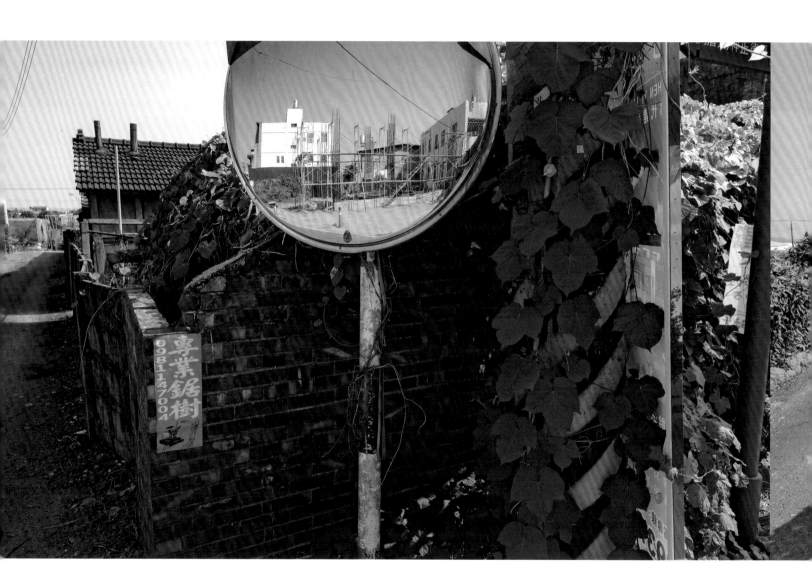

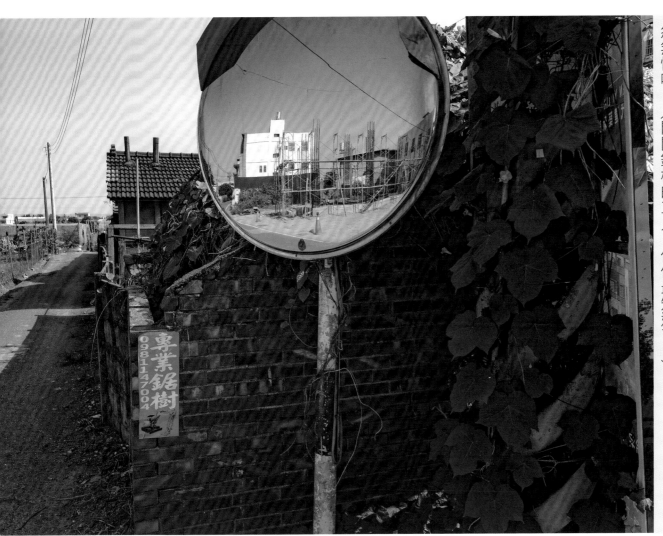

斜照的陽光，將右手邊的老舊房子，投射出一道厚厚的影子，空氣中沒有一絲絲麻雀的聲音，午休的工班也還沒有醒來。正前方，原本塗有反光安全漆的電線桿，幾乎被規律的蔓藤圖案給全遮蓋了。望著反光鏡中的建築工地，不禁自言自語：這年頭，做阿公的種樹、澆水；孩子爬樹、摘水果；孫子砍樹、蓋新厝。眼前的景觀真的是老人家周瑜打黃蓋，無怨無悔嗎？（問問鋸樹的工人，他們最知道了！）。

菜格批發商的大兒子半夜就去基隆八斗子批發魚、蝦。孩子很專業，當場就將貨品放在可以保持低溫的白色保麗龍盒子內，然後趕在清晨三點前，載回台北的南門市場。騎樓外，紅色太陽傘下的女兒，很知道如何和哥哥一起共用盒子：白色的蓋子做成廣告看板，再將稀有蔬菜放進盒內，販售體面的——孢子甘藍（原產地中海，含高量的蛋白質）；水葵（水塘的野生植物，口感圓融、鮮美滑嫩，含豐富膠質蛋白、碳水化合物、脂肪、多種維生素和礦物質）；黑蕃茄（原產於南美洲，濃郁水果香，酸甜適度）；攪瓜（瓜肉成絲狀，有人稱之為天然粉絲或素魚翅）。

「哪一個沒有良心，又不識字的車主，一大早就把車子丟在我攤位前？」「媽媽，這一次該輪到我打電話給拖吊車了吧？」（小孫女在一旁大聲的說著）

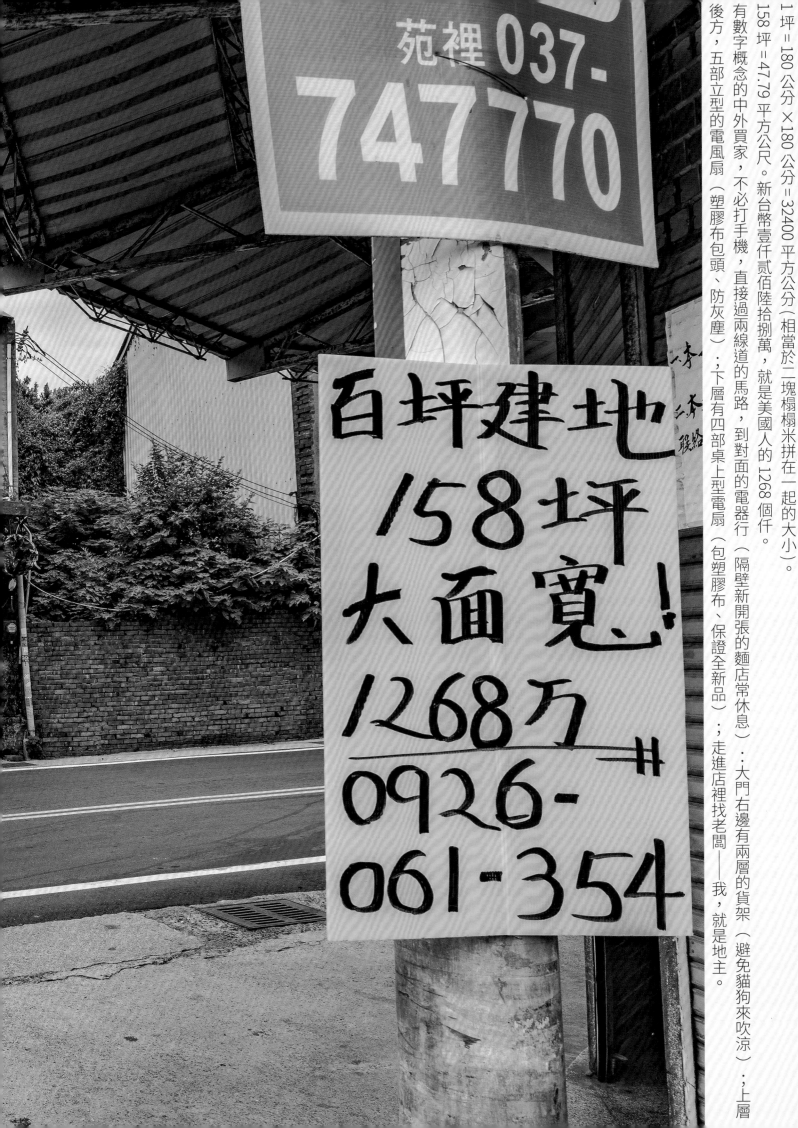

1 坪＝180 公分 ×180 公分＝32400 平方公分（相當於二塊榻榻米拼在一起的大小）。
158 坪 ＝47.79 平方公尺。新台幣壹仟貳佰陸拾捌萬，就是美國人的 1268 個仟。

有數字概念的中外買家，不必打手機，直接過兩線道的馬路，到對面的電器行（隔壁新開張的麵店常休息）‥大門右邊有兩層的貨架（避免貓狗來吹涼）；上層後方，五部立型的電風扇（塑膠布包頭、防灰塵）；下層有四部桌上型電扇（包塑膠布、保證全新品）‥走進店裡找老闆──我，就是地主。

A news from a friend through Facebook: The son of the oyster omelet vendor in the Shilin Night Mar ran away with the oldest daughter of an eminent Hakka chef from Sanyi. They hid in an old red-b residential compound at a small lane in Changzhi Village, Pingtung County. Inheriting recipes from t parents, the couple, a much younger husband married to a much older wife, were very good at cook Taiwanese and Hakka dishes. With very noisy tasks in the kitchen, the ding-ding-dong-dong of spatula hitting pots, woks, or bowls—Hakka peppered chicken, pig's feet in the family-style marinati anise sirloin, Dad's stew pork, sesame oil pork slices… there was nothing they couldn't produce. Facebook someone commented that the place was behind a narrow lane, drivers should be cautious not to scratch their cars. Men o date would be well advised not to take the challenge, but park the borrowed car far away and walk the rest of the way. Turn your right left to the lane and turn your left leg right to the end. After seven or eight minutes, walk past each of the households with a red door, a there you go—Finding Nothing Restaurant.

Because his girlfriend was pregnant, Ah-Chung planned his wedding three days before the lunar new year meet his responsibility no matter if he was ready or not. The date was not an auspicious day, and the astrolog signs of the groom and bride did not match. Did they have a pre-marriage physical examination? Never heard such a thing. Nonetheless, the weather was perfect on their wedding day; the procession consisted of the ca the groom's uncles and cousins who were in charge of firecrackers, the car for the bride, and the cars for the b men. The fleet of cars rode magnificently. They parked outside of the sugarcane field first; the groomsmen w out to check the car decorations, the rice strainer, and the bride's bouquet, among other things. A sugarcane w the only thing missing.

"Madam, we need one whole sugarcane plant to be carried on the car roof. It must be with roots and leaves, a v healthy plant."

"Here! Here you go! From parents-in-law to the newlyweds, and the offspring as well, all are blessed. The sugarcanes were just harves from the field behind this store. They remained so fresh that their roots were still filled with dirt, and their heads were still intact. With hea and tails, they symbolized endless lives."

"Madam, please prepare another two for our worship of heaven on the ninth day of the lunar new year. We will pick them up on our w back. Oh, the zodiac sign of the bride is a tiger, for your information."

"It's alright, just skip the raw pork."

In a traditional wedding, the groom and his family tie red envelopes and pork with red string at the root of a bamboo or sugarcane plan distract the evil spirit called White Tiger. In the case that the bride's zodiac sign is a tiger, there is no need to use pork.

With a performance bonus filling my chest pocket, I drove my family in silver sedan to celebrate with a feast in the mountains. It rained a lot the days and was very humid in the mountain area. Cars from the oppos direction often blinded me, but I kept a steady pace. We finally pass the concrete bridge and turned right, arriving at our destination. My w and my daughter started to barbecue, and I sat by a stone table to ma tea. A boy next to us was singing karaoke out-of-tune. For some reas the Chicken House Restaurant stopped providing indoor fishing for their customers. It was a pity, we had expected to catch fish or shrir After the meal, the store owner invited us to a general store he had opened last week for his newly wed daughter-in-law from Bangkok. shelves were stocked with all kinds of products, like undergarments for men, women and children, rice cookers, lithium batteries, impor condoms. . . everything—you name it. Turning around, there were marble sodas, a mark of old times, displayed in a corner. The Bang bride saw us and greeted us with awkward Chinese mixed with English, "Welcome! Betel nuts free, soda no straw."

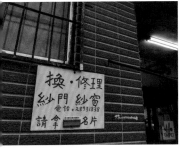

A voice came from behind the rusted frame and glass window, "Hey, looking for my dad to fix a screen window? He is out for work."

"Tonight? Sorry, his schedule is full tonight and won't be available until tomorrow."

"... Aunty, you are in a hurry? Let's see… 11:40 tomorrow morning, is it OK?"

"... OK, 11:35 in front of your door."

"Please give me your address. Slower, please, I am only a fourth grader, I can't write fast enough."

"... Aunty, you want it to be earlier, at 11:00?"

"My dad told me to charge 28 for changing the time, and if the appointment is moved earlier, we charge other 93 bucks."

"OK, giving you a discount of 8 bucks. Materials and labor will have to be calculated by the master repairman on-site, there is no bargain master repairman's numbers."

"Aunty, sorry, I did not notice you live on the fifth floor. Dad is no longer young, and it is hard for him to carry the tools and materials stairs, so we charge 38 bucks for each floor."

"All right, no more discount, OK?"

"Hm, hm, I heard you. Aunty, you said your oldest daughter-in-law next door also needs to replace a window screen?"

"s, both cases can be handled tomorrow. Does this sister, your daughter-in-law, have a fax machine? I can fax our catalog to her first. No rge for faxing."

"rry, aunty, because the replacement of the door screen and window screen will take the master repairman's time over lunch, please pay his lunchbox. You can decide how much."

"Oh, you need to think about it a little bit longer?"

"nty, allow me to remind you, you will have to pay the charge for changing the time in the next phone call. Thank you for calling, and you welcome to visit us in the market."

"baby girl, bring your dad some toilet paper. I dropped the whole roll in the toilet."

My baby sister Pao-Chun has beautiful shoulder-length hair, she was envied by people in our neighborhood. After she finished school, our oldest sister arranged a job in a chain hair salon on Donghuan Road in Hsihu Township. Pao-Chun studied how to wash, cut, perm and style hair for customers. The salon owner was impressed by her cleverness and helped Pao-Chun set up her own store in Datu community to provide special hair treatment. Three days before her store's opening, Pao-Chun had a big quarrel with my nagging husband. She left her scooter that she cared so much about, and disappeared completely. Helpless, I forced my very pregnant body to move her equipment into our home at the end of the lane, and provided hair services to our acquaintances in the living room.

Over the past three years, the bonsai left behind in the store has thrived from rainwater leaking through the ceiling.

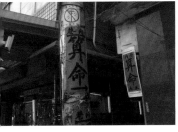

Majored in the wrong subject as a youth? Entered the wrong business in adulthood? Picked up the wrong spouse in middle age? Come along, in the small alley there is a fortune teller who can let you take a peek into your past and your future. There is a fortune telling service, turn right here and walk to the end of the alley. It is secretive and taciturn. The place has its own diesel generator, 24 hours a day, it's never had a power outage. "Deep Alley Fortune Teller", the authentic expert who helps you pursue good fortune and avoid disasters (It is the only place providing such an unusual service, do not enter the wrong alley). Expertise: Ziwei Astrological Chart (not to be confused with the tactics of astronomical nen Dunjia interpretation), horoscope, divination, and tarot cards. The service will be filmed, affirmed and authenticated by a court of law. ur privacy is absolutely guaranteed.

owner of the jewelry shop looked at me and my wife for a long time. Then he walked out to tell us, "My store provides all kinds of ducts, and the prices are fair. If you don't believe me, you can ask the fortune teller."

I've lived in Changhua for almost my entire life. Today around nightfa visited the Wendeh Temple in Huatan. Outside of the restrooms, I he a woman and a man talking on their cell phones.

The middle-aged woman spoke Mandarin with a Beijing acce exaggerating her 'r' retroflex sounds, "Chang Sir, when my ex-husba paid you the deposit, didn't you guarantee that the man was heal possessing a house and a car, with a stable income and no debt? also said this man has no convict record, no addictions, and wouldn't force his wife to have children? The man I meet now shares a ho with five or six friends, he rides a bicycle and is addicted to going to banks to pay bills with extended credits of five accounts. Furthermo he wishes to have sex with me three times a week, with a condom…"

The man wearing rubber slippers grabbed the mobile phone from her and shouted with a heavy Cantonese accent, "Before I paid y didn't you promise the woman must be taller than 155cm, fair face, good shape, who has a decent occupation and a simple life? Now woman standing in front of me has a student haircut, no curves at all under her shoulders. And she is a full-time mother of five children!" On the other end of the phone, a voice said in a calm tone, "you were matched by a computer, all the conditions you required are met."

Before attending the gathering with my old pals for the establishment of the Taiwan Republic, one should eat f since the gathering usually doesn't provide meals. Food with Tea Pairing? 1.5KM ahead… Food with Tea Pairir 1.5KM from here, no problem! But my doctor told me that drinking tea while eating would hinder iron absorption, a theophyllines from the tea might deteriorate proteins and result in indigestion. Beef steak should not be paired w strong tea… seeing my hesitancy, the scooter boy approached me casually, "Don't worry about the walk, I will g you a ride on my scooter! The restaurant is new, Food with Tea Pairing, it is very, very good!"

He showed me an app on his phone, a luxurious dish of "rice in soup for the white-collar class". It is served a ceramic bowl imported from Japan(not the cheap plastic pink bowlsGreen tea will be served before the me followed by top quality white rice(choices include Yuekuan, Chunghsin, Hsilou, Hsizhou and Shanhe) dappled v sencha(genmaicha or oolong) and katsuobushi(instead of cheap seaweed powder). You eat with stainless st spoons made in Italy(not disposable bamboo chopsticks). Seeing that I wasn't moved, the scooter boy said in a low voice, "How about t after the meal, I will ask the restaurant manager to give you a coupon for the Jinjin Eatery and take you back here. I'll open the door a treat you to free karaoke. What do you think?"

Does the karaoke store provide erotic services?

Of course not!

"The well-known and very reputable Yutien Lion Dance Training?" I know! But I heard from the sch principal that its workshop was full. The poster, attached to the tree trunk that called for trainees, h been torn away last month.

"High quality but affordable B&B?" Turn around.

"Yutien Agricultural Classroom?" Go across the road.

Driving along you will arrive at the Luodong Night Market. Drive further is Suao where there are c springs. Fill your fuel tanks, it takes two hours to Hualien if you are not caught by traffic on the Suhua Highwa

"Nothing sounds interesting?" Alright then, go to the barbershop opposite the road.

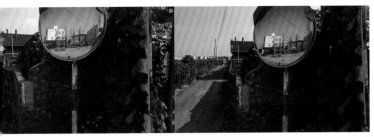

Slanting sunlight cast a long shadow on the dilapidated house on its right side. The air is quiet, not even a sparrow's chirp is heard, and workers are still in the middle of their afternoon naps. In front of me an electric pole covered by reflective paint is evenly traversed by a vine. Seeing the construction site in the mirror, I can't help but grumble: the trees planted and watered by grandpa,climbed by children picking fruit, had all been chopped down by grandchildren for new buildings. Do regret their decisions? (Ask the tree choppers, they will know.)

The oldest son of a market vendor went to the Badouzi Fish Market in Keelung at midnight to buy fish and shrimp, among other seafood. He worked skillfully, putting the products into a white styrofoam box to keep them at a low temperature. Before three o'clock in the morning, he carried them to the Nanmen Market in Taipei. Outside the building's corridor, the girl under a red umbrella was good at making use of her brother's white styrofoam box. She made a sign with the lid, and put precious vegetables in the box: Brussel Sprouts(originally from the Mediterranean, high protein content), Oval-leaf Pondweed(wild plants from a pond, fresh and smooth in taste, high in collagen, carbohydrates, fat, multiple vitamins and minerals), Black Tomato(originally from South America, rich & fruity, perfect combination of sour and sweet flavors), Spaghetti Squash(with spaghetti-like meat, it is also called natural fine noodle or vegetable shark fins).
"Who is the god-damned illiterate driver parking the car in front of my stall?"
ommy, it's my turn to call the tow truck, right?" The little granddaughter of the vendor family shouted in response.

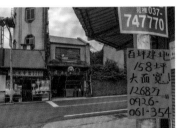

One pin = 180cm X 180cm = 32400 cm2(about the area of two tatamis)
158 pins = 47.79 m²
12.68 Million New Taiwan Dollars, or 1268 thousand NTD
Local or foreign buyers with a good sense of numbers don't have to use their mobile phones to make phone calls. They walk across the two-lane road to the appliance store(the new noodle shop next to it takes a break today). The shelves on the two sides of the store front(to block dogs or cats) display five pedestal fans(covered by plastic bags to protect them from dust) on the top , and four desk fans on the er shelf(covered with plastic bags, guaranteed brand new products). They walk into the store to find the shop owner—me, I am the 158-land owner.

In the winter of 2019, my life was a day-night reversal as usual. In the early morning, I parked my car at the underground parking lot of the dorm for quality control engineers, and switched off the radio, which had been playing A-Mei's "Blue Sky" on FM 106.1. There was no elevator, I walked up to the ground floor and pushed open the gate. I took out a pair of sunglasses from my pocket to shade my eyes from the dazzling blue sky. Walking past a school fence, a scene flashed in my head: during the spring semester when I was in the third grade, a week before the summer vacation, I ditched classes and ate my lunch at the bus terminal. A blue sky emerged in my mind. And one time in the first year of junior high, during baseball game before midterm exams, I, the pitcher, struck out a batter by having the white ball sliding away from my delicate fingers, ving three runners left on base. In the deafening cheers, I felt the blue sky holding me. Several years later, after I missed the top versity admission with just one point short in the entrance examinations I had taken the second time, I walked to the art center behind university where I had enrolled during the noon of the day for freshman orientation. In my field of view there were two high chimneys far ay, with the bright blue sky in the background. Then six years had passed and I'd made it through graduate school in the US. One day t on a stone stool outside the skating rink in NYC's Central Park by myself, my application for an internship in hand. In the remote sky, k clouds gradually gathered in my direction. Before the blue sky was completely covered, I stood up and went back to pack my stuff for return to Taiwan.

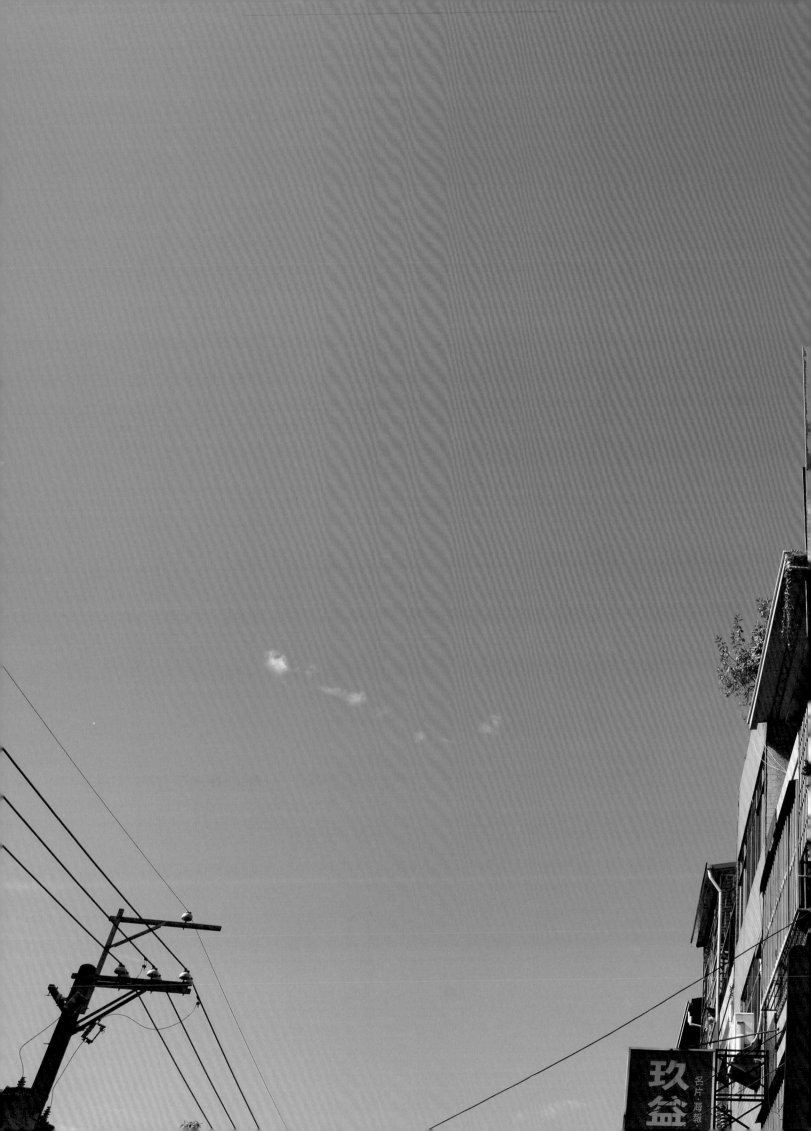

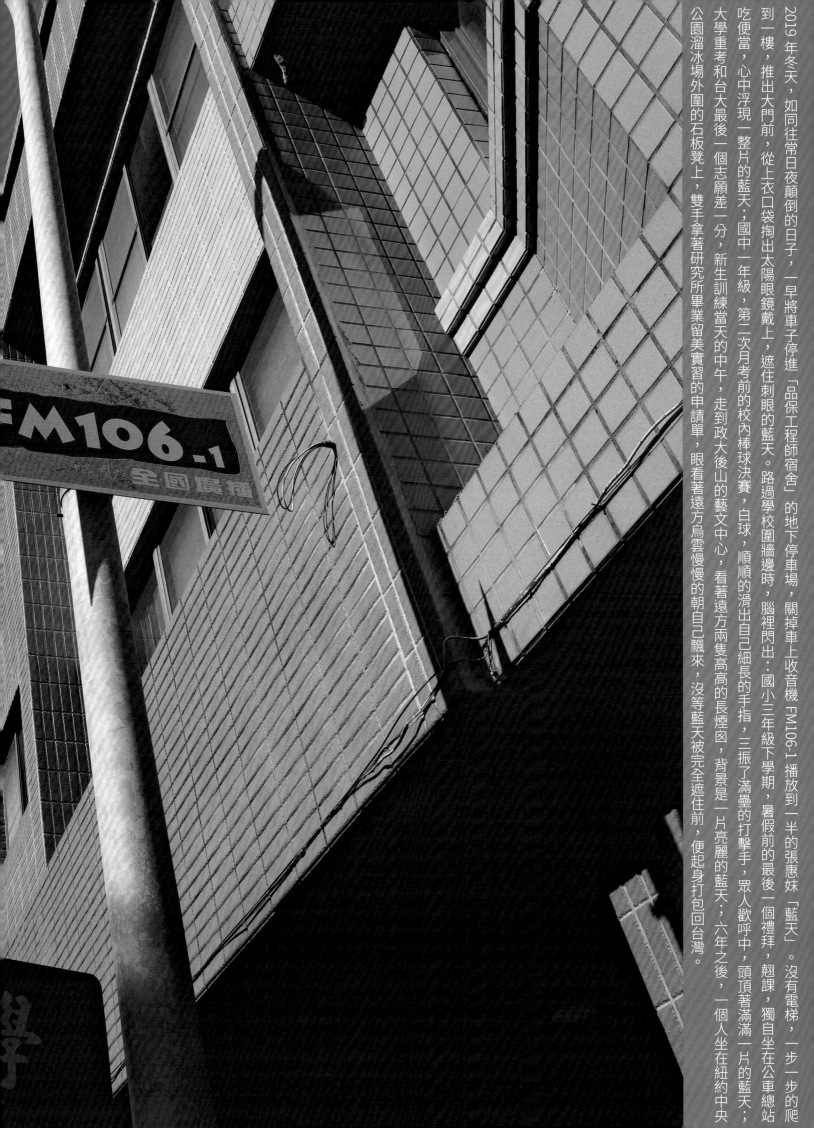

2019 年冬天，如同往常日夜顛倒的日子，一早將車子停進「品保工程師宿舍」的地下停車場，關掉車上收音機 FM106.1 播放到一半的張惠妹「藍天」。沒有電梯，一步一步的爬到一樓，推出大門前，從上衣口袋掏出太陽眼鏡戴上，遮住刺眼的藍天。路過學校圍牆邊時，腦裡閃出：國小三年級下學期，暑假前的最後一個禮拜，翹課，獨自坐在公車總站吃便當，心中浮現一整片的藍天；國中一年級，第二次月考前的校內棒球決賽，白球，順順的滑出自己細長的手指，三振了滿滿的打擊手，眾人歡呼中，頭頂著滿滿一片的藍天；大學重考和台大最後一個志願差一分，新生訓練當天的中午，走到政大後山的藝文中心，看著遠方兩隻高高的長煙囪，背景是一片亮麗的藍天；六年之後，一個人坐在紐約中央公園溜冰場外圍的石板凳上，雙手拿著研究所畢業留美實習的申請單，眼看著遠方烏雲慢慢的朝自己飄來，沒等藍天被完全遮住前，便起身打包回台灣。

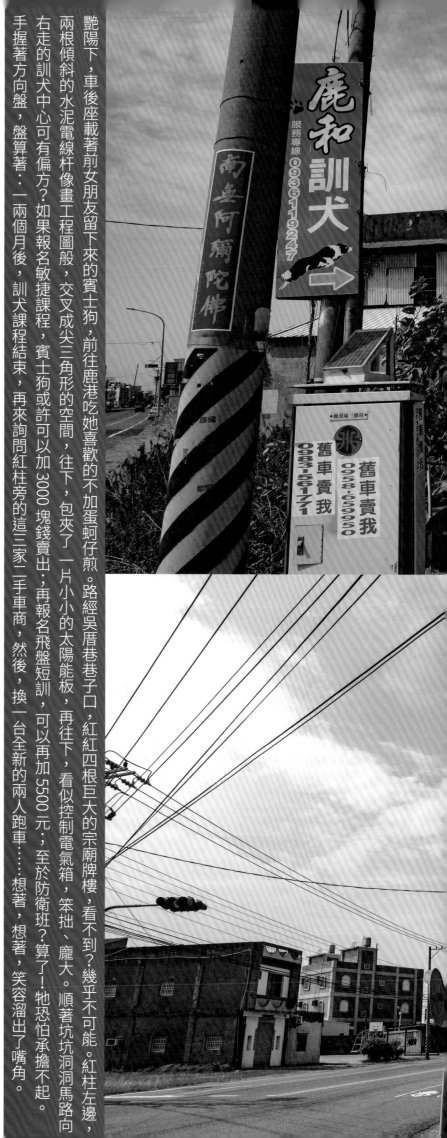

艷陽下，車後座載著前女朋友留下來的賓士狗，前往鹿港吃她喜歡的不加蛋蚵仔煎。路經吳厝巷巷子口，紅紅四根巨大的宗廟牌樓，看不到？幾乎不可能。紅柱左邊，兩根傾斜的水泥電線杆像畫工程圖般，交叉成尖三角形的空間，往下，包夾了一片小小的太陽能板，再往下，看似控制電氣箱，笨拙、龐大。順著坑坑洞洞馬路向右走的訓犬中心可有偏方？如果報名敏捷課程，賓士狗或許可以加3000塊錢賣出，再報名飛盤短訓，可以再加5500元；至於防衛班？算了！牠恐怕承擔不起。手握著方向盤，盤算著：一兩個月後，訓犬課程結束，再來詢問紅柱旁的這三家二手車商，然後，換一台全新的兩人跑車……想著，想著，笑容溜出了嘴角。

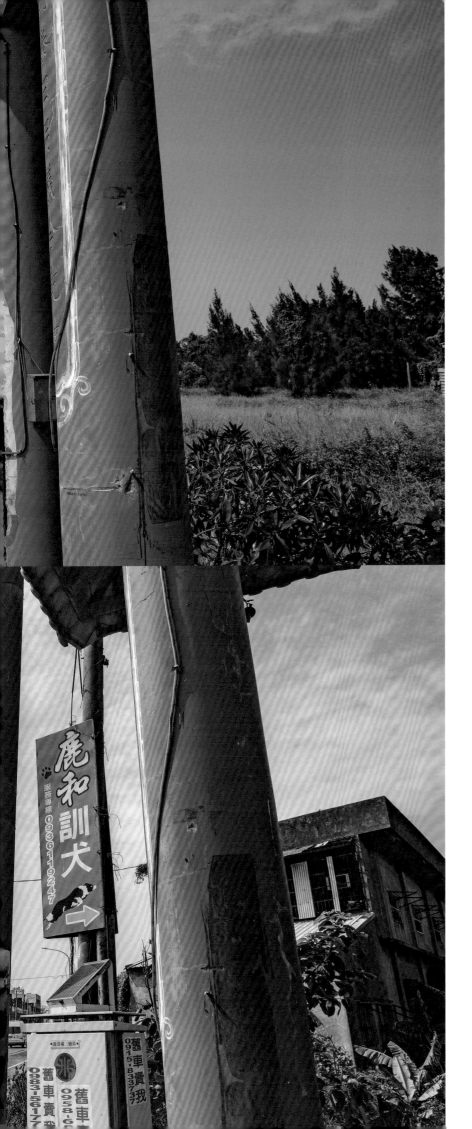

我們霧峰，因水氣充足、常有霧氣而得名，是前臺灣省議會的設置地，這一點常識你是應該知道的！在我們正前方，那根傳統洗石子柱上的內衣招牌，雖然有些破舊，但可是大有來頭。當年老師傅跟著軍隊，從上海來到這裡，就專門替達官貴人的太太、女兒、小三縫製內衣。柱子，可是一個將軍派他的工兵班長來做的，並且還親自題了字。老師傅退休後，倒是有聽說，嫁到美國的女兒帶著唯一小孩回到霧峰，在家裡代理美國名牌的內衣，那個叫做什麼「為多利的秘密」來的。反正，一家人很少出門。……

聽到到這裡，自己仔細看一下，見證霧峰發展的招牌柱，不知道何時被一座鐵灰色的電氣箱給擋在前面，附近人家油漆時，還不小心滴了一塊白漆在上面，旁邊那張褪色的貼紙，是保證書的號碼？夾在石柱和電器箱間的灰水管更又是做什麼的？巷子裡傳來女人的聲音：「處喻，功課寫完了沒？騎車幫媽媽去送貨喔！」

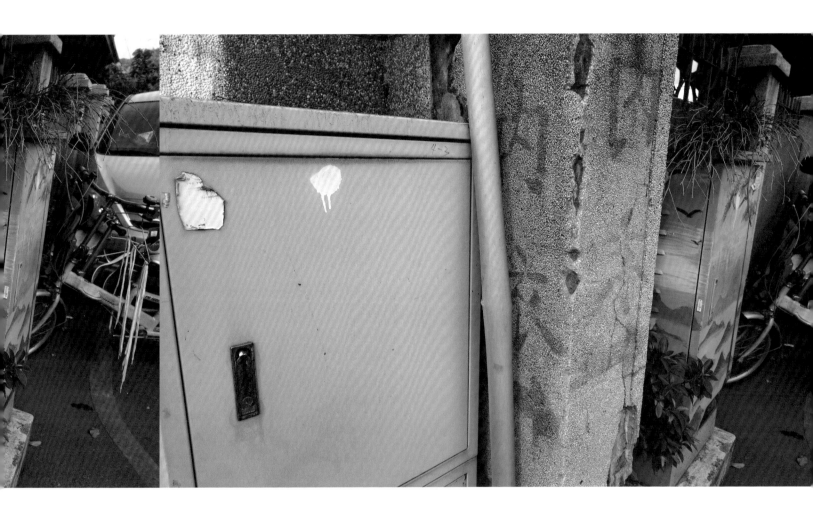

年初以來，我們南投的雨水便嚴重不足，集山路旁的枯樹處處可見。想著……想著，三輛晶圓廠的運水車，在面前呼嘯而過，應該是想趕在周末輪流停電前回到工廠。

星期六補班的日子，鎮上僅存少少的相思樹旁，小學同學志豪為向來話不多的建宏點著煙，昨天晚上才認識的承恩，獨自坐在石頭上，兩眼盯著對街發呆。正午時刻，

台雞店內甕仔雞，啼！啼！啼！

「3號桌晴姊，麵小乾、蔥少、麻油多。」

「8號桌淑芬姨，大陸妹燙、半鹽、半油、蔥多，自備便當盒。」

「外帶怡君妹，半雞走、頭對切、尾不要、青筍排骨湯，不要筍。」

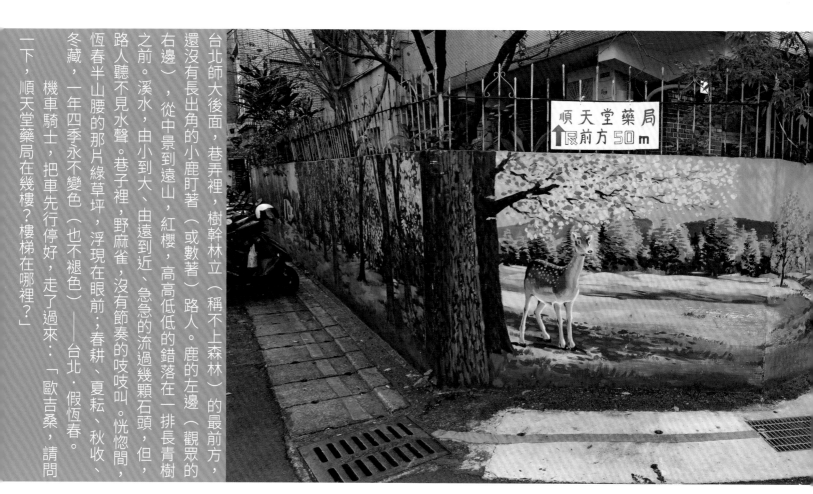

台北師大後面，巷弄裡，樹幹林立（稱不上森林）的最前方，還沒有長出角的小鹿盯著（或數著）路人。鹿的左邊（觀眾的右邊），從中景到遠山，紅櫻，高高低低的錯落在一排長青樹之前。溪水，由小到大、由遠到近、急急的流過幾顆石頭，但，路人聽不見水聲。巷子裡，野麻雀，沒有節奏的吱吱叫。恍惚間，恆春半山腰的那片綠草坪，浮現在眼前；春耕、夏耘、秋收、冬藏，一年四季永不變色（也不褪色）——台北·假恆春。

機車騎士，把車先行停好，走了過來……「歐吉桑，請問一下，順天堂藥局在幾樓？樓梯在哪裡？」

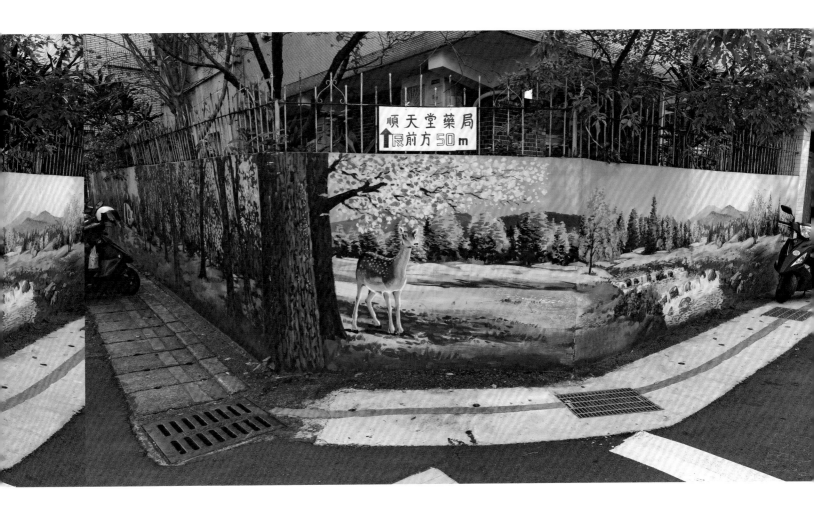

順天堂藥局
正前方50m

午間電視新聞：今天早上，散戶投資客大舉回籠，台股 V 型反轉，屢創歷史新高，許多八年級生開戶進場投資⋯⋯。

下午的導師課，我對著即將畢業的學生說：「天上飛來財富是好夢，你們這一群網路的原生世代，大量湧入股市學習理財，很好！只是，股票投資除了眼觀四面、耳聽八方之外，更要了解，自己的性格會影響投資的成敗，投資期間，不但要重視投資的紀律與耐性，尤其要了解的是，投資不是你知道甚麼，就能得到甚麼，所以不是每一個人都適合做股票夢。以我為例，就只會每個月到彩券行做一點定額的發財夢。」

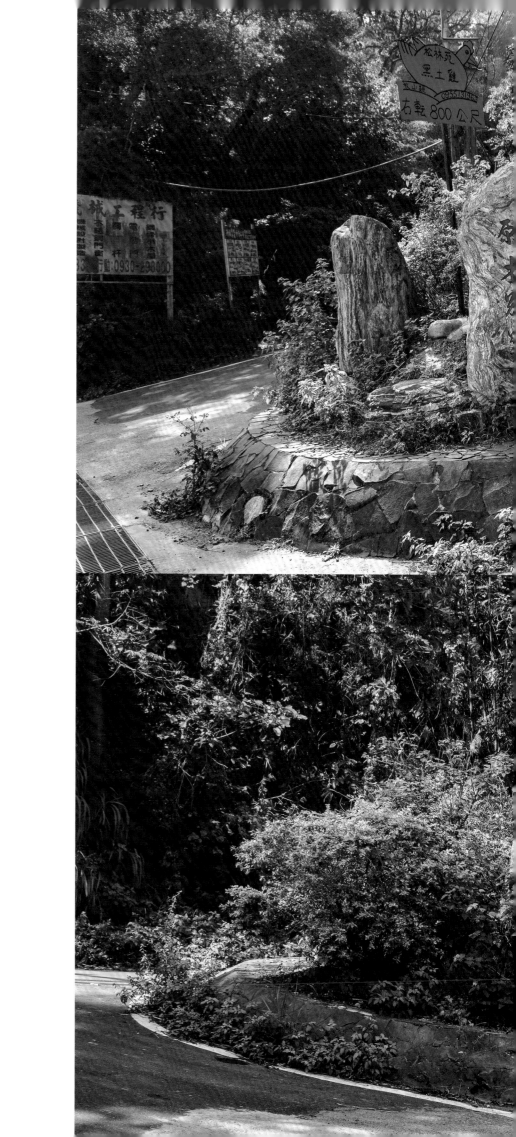

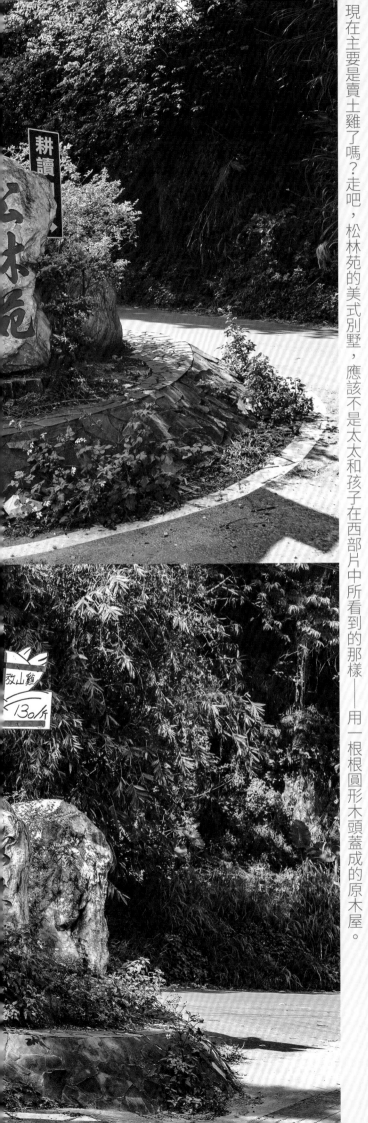

上個禮拜外出洽公，無意中看到松林苑美式原木別墅的廣告，下午一家人興奮的來探查一下。找了好久，終於在前方斜坡，小碎石、大石塊錯落堆疊的迴轉島上，看到松林苑的地標了。但是，坡斜路窄、彎度大，我的直覺：車身鐵定容易擦傷。於是，把車停在新做好的水溝蓋上，環視一下周遭：工程行的廣告牌長滿了青苔。

生意差，附近生活的機能不好嗎？所以有很多房子都想脫售？太太問，耕讀園有替孩子上輔導課嗎？高三的大兒子問：建商是不是把賣不出去的房子都改成雞舍，

現在主要是賣土雞了嗎？走吧，松林苑的美式別墅，應該不是太太和孩子在西部片中所看到的那樣——用一根根圓形木頭蓋成的原木屋。

63

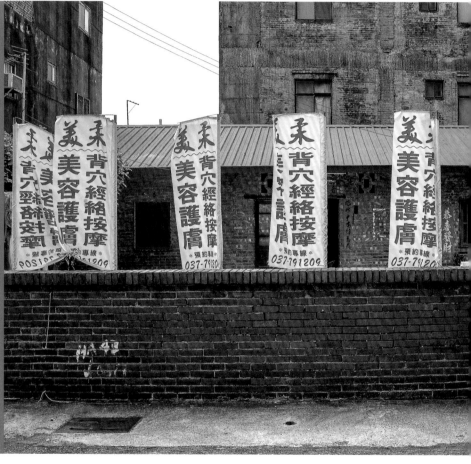

兩面下斜，紅色的鐵皮浪板，一前一後，架在正面和右邊的紅磚牆上；直式，紅底金字的恭喜發財，貼在紅牆上；有財神圖像的，貼在紅色門柱上。屋主，利用鄉公所修理地下水道的機會，拜託工班把院子覆上一層水泥，老舊的地面煥然一新，恭喜！恭喜！

大年夜，小朋友恭喜發財；大年初一，未成家的孩子，恭喜發財；大年初二，出嫁的女兒回娘家，老爸、老媽恭喜發財；正月十五元宵，未來的親家帶著聘金來喝茶，老爸、老媽恭喜發財。老媽趁著老爸午休時刻，靜靜的換上用紅包買的紅彤彤新衣、快步走出紅門、繞過白鐵水塔，到大廟前新開的美柔館，兌換了第一張的貴賓卷：背部穴道經脈按摩，面紅耳赤；全身美容護膚，紅光滿面。

老媽心裡暗爽：懸掛一面廣告旗，送一張貴賓卷，剩下的四張，下次自己再來。

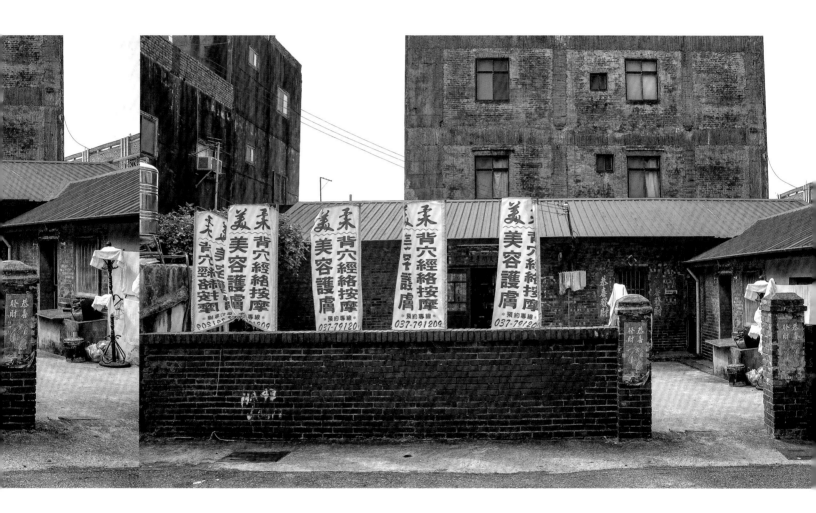

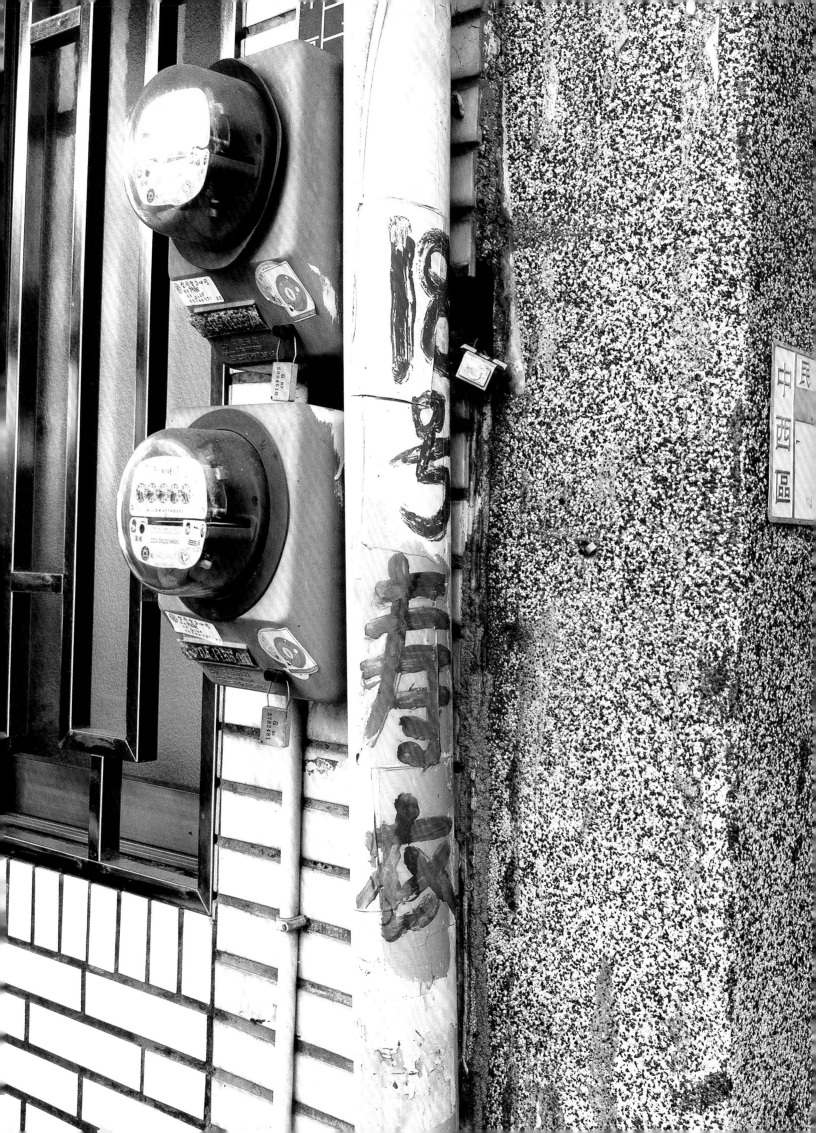

一年前，我從有風車的荷蘭來台南做有關於中國結婚禮俗的研究。有一天傍晚逛街時，看到店家招牌寫著「老嫁妝」，便笑著跟一旁的台生說：「你們台灣人結婚，女生嫁妝的內容就已經非常有文化了，沒有想到，嫁妝居然還會依年齡不同而有所區隔！」（台生掩嘴笑）在我強烈要求下，幾個人一起結伴走進店裡。哇！玻璃櫃陳列了好幾件色彩鮮艷、中式圖案、整排扣子到頸的傳統服飾。心想，太好了！可以寄幾件回老家當聖誕禮物。仔細再看一下這些衣服，全是棉質，沒有綢緞或皮革等其他的選擇。老闆注意到我們看得入神，便從板凳上站起來，迎向前來嚴肅的說：「衣服應該不是買給自己的吧？」（這句話我聽得懂）說著，便在我們眼前攤開一件，讓我們可以看清楚一點。

哇塞！闊袍大袖的設計果然很特別，但，不知為什麼，袖子似乎長了一些些？我還注意到，櫃子下方有幾件衣服的正面，都縫有一條細長的白布。真想問老闆，這可是今年最時尚的流行款？（台生不敢替我翻譯），無意中看到玻璃櫃上貼著小紙條：「一＝300，三＝750」於是，我鼓起勇氣問老闆：「兩件多少？四件是不是更便宜？」

老闆──眉皺；衣服，折好，入櫃；話不說，坐回，板凳。

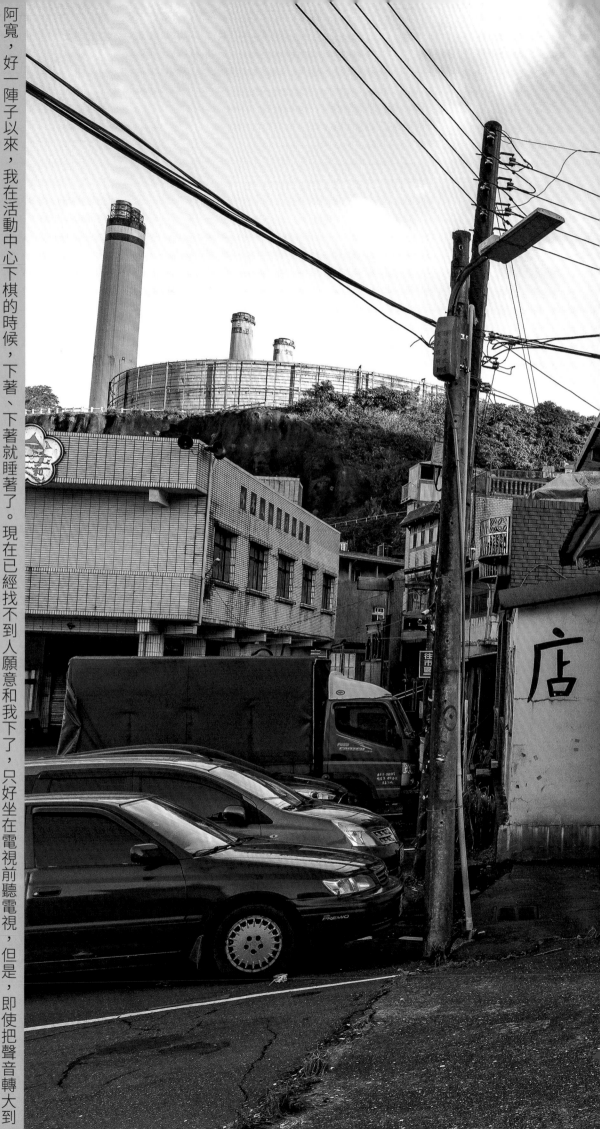

阿寬，好一陣子以來，我在活動中心下棋的時候，下著、下著就睡著了。現在已經找不到人願意和我下了，只好坐在電視前聽電視，但是，即使把聲音轉大到鄰居都來抗議了，還是聽不清楚。這一陣子，你嫂子阿英麵店的生意很好，你媽媽，每天都去幫忙洗碗到很晚才回家。家裡附近的協和電廠還在燃燒者重油，自從 2013 年它把荷蘭來的黃色巨鴨變成台灣燻鴨的新聞結束後，再也沒有人來問電廠在哪裡了。油煙這麼久了，會死的人早走了，留下的就是沒有感覺。還記得岸邊賣杏仁茶加油條的小攤嗎？以前，漁夫都要排隊，現在的新老闆，只在週末傍晚過來，用熱水沖泡來自泰國的即溶咖啡包，加上油炸的空心小饅頭，叫什麼「多納」來的。你知道的：阿公傳下來的雜貨店，已不再提供討海人必備的泡麵、醬菜、阿兵哥餅乾，我現在都到台北迪化街批發抽樂、竹水槍、尪仔標、太空氣球、巧克力牙膏、口紅棒⋯⋯主要賣給台北人。對了，我把店外面的小空地，沒有讓市政府知道偷偷畫了一個臨停的車位，給自己賺一點香煙的錢。

至於你大哥，跟你以前一樣，常開船到公海把有補助的油料賣給對岸的漁船，上個禮拜，美國的紐約時報刊登，這些油最後轉手賣到北韓，他因此被帶去問話三天了。你嫂子一邊煮麵一邊擦眼淚，我又沒有足夠的錢可以找議員幫忙。

對了！阿寬，裡面的伙食還好嗎？需要送「兄弟餐」嗎？

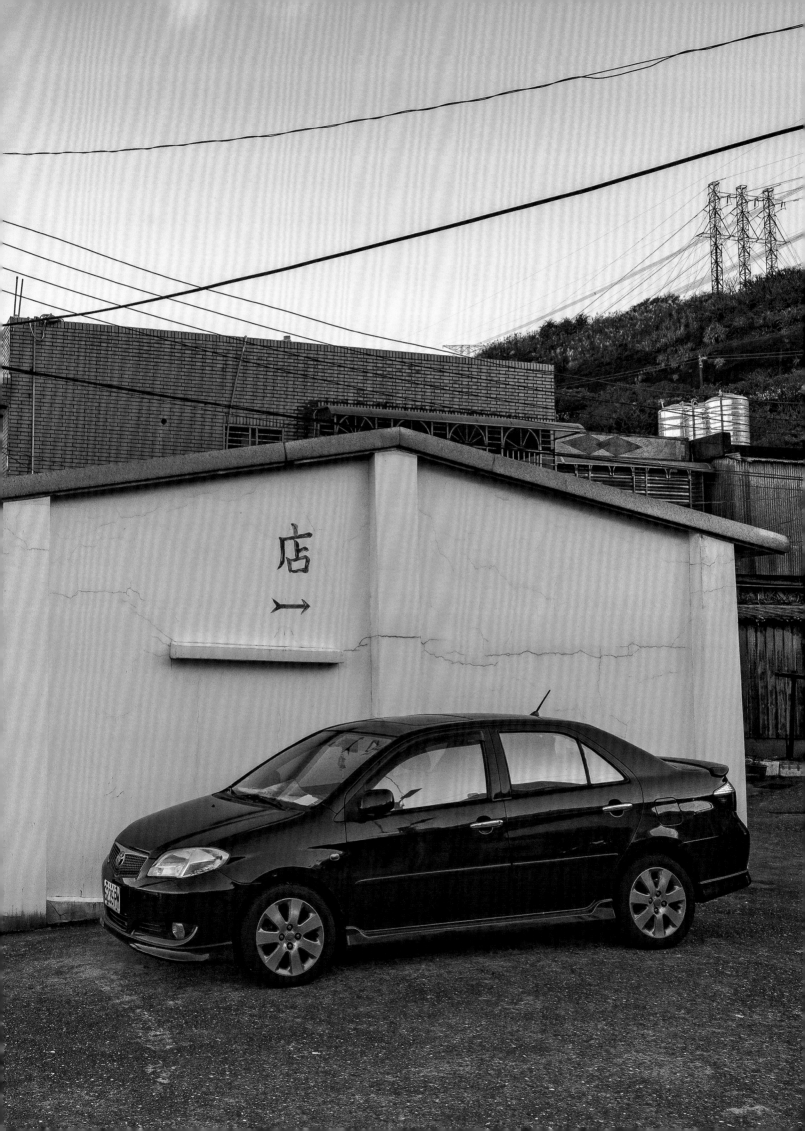

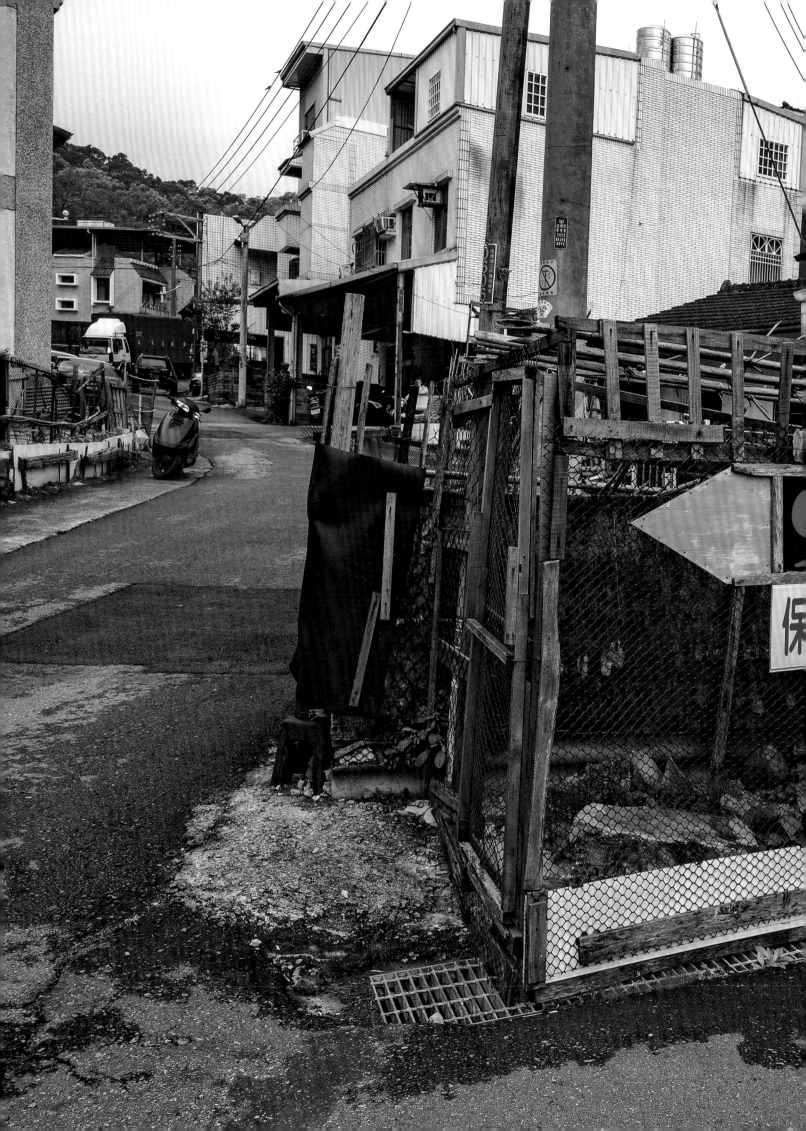

995之家＝「酒酒·舞」嗎？所以，藍色箭頭將引導我去一個可以忘掉憂鬱的地方？995之家＝「消費1000塊有找？」好想知道，如果是買保健食品，不知道

有沒有「張家」的蓋章作保證？沿著神秘的招牌右邊上山，會和白色公寓後面的大路相連？下回找個男生作伴，再來探險。喝一口水，看了看正前方，道路交會處：兩根水泥電線桿（一根上面有標示造橋鄉公所）和另外一根木頭的電線桿，一起圍出了一座不規則形狀的菜園，讓人傻眼的是：裡面種植的東西都不確

定是否能吃（或好吃），但還是特別設了一扇門！（應該是防貓狗吧？）小菜園，下方有三塊白長條的隔板，頂在水溝蓋的上方；一個比人還高的黑網，上

緣一長排、褪色、條狀的短木料，圖案還算整齊，但，看起來像是撿來的。整體而言，園子釘得亂七八糟，可是主人心情不好的發洩？還是，老一輩習慣性的

省錢？再細看，道路旁，那一塊黑塑膠布不知道遮了什麼？過馬路，左邊還有一座類似的園子。一輛紅色的摩托車靠邊停著，騎士可是跑到巷子底幫忙協調大

貨車和小旅行車的交通事故了？掏出手機看一下時間，該去搭車了。

95之家

37-563365 張

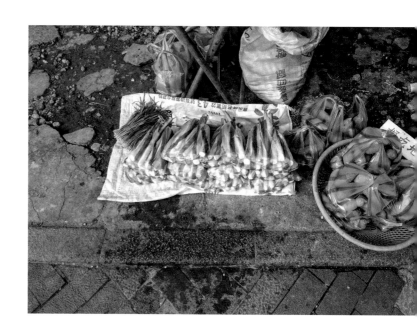

Under the scorching sun, I ride with the black-and-white faced dog left by my ex-girlfriend sitting in the rear sea[t] my car to Lukang. I am going to eat an oyster-omelette without the omelette, a dish she loved. As I am passing [the] entrance of Wu Lane, the four huge red columns of a temple gate are in sight, no way to ignore them. On the [left] side of a column, two tilting concrete electric poles form a sharp triangle like a construction diagram. Under th[em] is a small solar panel standing on an awkwardly oversized power distribution box. Riding along the road with m[any] potholes, the dog training service is on the right. Does it have unusual ways to make this dog a better pet? Perh[aps] after the agility training, I can sell this dog for an extra 3 grand? And after frisbee training, another 5.5 grand? H[ow] about the personal protection training program? Forget about that idea. This dog might not be able to endure it. Steering wheel at hand, I am calculating, after a couple of months, when the dog training programs are over, I s[hould] stop by the three pre-owned car dealers by the red columns. Once my car is sold, I am going to have a brand n[ew] two-seater sports car… and, and… I can't help but grin.

Our place Wufeng(Fog Peak) was given the name because of its humi[dity] and fogginess. It was the former location of the Taiwan Provincial Coun[cil.] I suppose you all know about it, it's common knowledge. Before our ey[es] on the stone-washed concrete column is the sign of an undergarm[ent] store. It looks old, but the store marks a significant history. The tailor ca[me] to Taiwan from Shanghai with the military, and his clients were the wiv[es,] daughters and mistresses of those high-ranking officials and dignita[ries] from China. This concrete column was manufactured for his business by an engineering troop officer sent by a general. The general a[lso] inscribed some words on it for the tailor. We were told that after the tailor retired, his daughter who got married in the US had brought [her] only child back to Wufeng. Based on her family business she became the representative of a high-end brand of American underwe[ar] called… called Victorian Secrets? Anyway, the family is hardly seen because they seldom go out. . .
The story ends here. Taking a closer look at this column that witnessed the growth of Wufeng, there is an iron gray power distribution [box] blocking it. And a drop of white dot on it probably was from the work of painting nearby. Is the sticker on the upper right corner the warr[anty] certificate with serial numbers? And what is the purpose of the gray pipe between the concrete column and the distribution box?
A woman's voice is heard from the alley, "Zhu-Yu, have you done your homework? Deliver these goods for Mom with the scooter, will you[?"]

Since the beginning of this year, Nantou has been in a devastating drought. Without rain, trees by [the] sides of Jishan Road are dried out. When I was lost in my thoughts, three water transporting trucks [from] the chip factory roared past me. They must be hurrying back to the factory before the scheduled pow[er] outage on the weekend. On a Saturday when most of the people were working to make up for [the] delayed work, we hung out by the few surviving Formosa Acacia trees. My elementary classmate C[hih]-Hao lit a cigarette for Chien-Hung, a very quiet man. Cheng-En, whom I met last night, sat on a la[rge] stone by himself, staring absentmindedly at the street. At noontime, chickens in the restaurants bega[n to] crow, "Bok! Bok! Bok!"
"Sis Ching on Table 3 orders a small dry noodle with less green onion and more sesame oil."
"Aunt Shu-Fen on Table 8 wants boiled lettuce with half salt and half oil of average seasoning. She brought her own lunchbox a[s a] container.."
"Young sis Yi-Chun wants a half of a whole chicken for takeout, including half of the chicken head. But she doesn't want the chicken [butt.] She also ordered a stem lettuce pork rib soup, hold the stem lettuce."

In the alley behind the campus of a university, at the front of a bunch of trees(not as dense as a forest), a fawn before developing antlers is staring at or counting the numbers of bypassers. On the left side of the fawn(the right side of the audience), from the middle scene to the remote mountains are cherry trees with pink blossoms standing high and low in front of a row of evergreen trees. The creek widens and extends from the background to the foreground, flowing fast passing over the rocks. Unfortunately, the sound of ashing water is not heard. Instead, sparrows chirp wildly in the alley. In a trance, the emerald grassland on the hillside in Hengchun(literally "forever ing") emerges before my eyes. But here is a scene that never changes and never fades, no matter if it's sprouting time in the spring, or the time ploughing in summer, or for harvest in autumn, or for storage in winter. It is a fake Hengchung in Taipei.
an parked his scooter and walked over, "Excuse me, sir, which floor is the Sun Ten Pharmacy? And where is the staircase to it?"

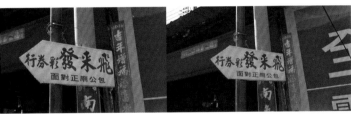

On the midday TV news: "Individual investors rushed back to the stock market this morning, causing a very sharp bounce. The indexes broke historical records several times as many young investors in their twenties joined the market..." In the afternoon class, as the class mentor, I told these students who were leaving school soon, "Fortune falling from the sky is a dream. Living in an era of the Internet, you have multiple methods learn about investing, which is a good thing. But bidding in the stock market, you not only need to gather information and tips from all ssible channels, but you also need to know how your personality would affect your decisions in your investment, in case you win as well you may lose. Principles and patience are crucial to each investor, and one should also face the reality that your knowledge doesn't help u make a profit. Not everyone will be a good player in the stock market. Take myself as an example, each month I will spend a certain ount of money to buy lottery tickets."

Last week I went on a business trip and accidentally saw an advertisement that an American-style log villa called Pine Garden was for sale. This morning my family came with me to explore it. We were excited, but it took us a lot of effort to find the place. In the roundabout on a hill ahead, a pile of large and small rocks was the landmark for Pine Garden. But the road along the hill was narrow and the turn was sharp. I figured that if I drove through the tight lane, my car would be scratched so I parked the car over the drain grates, which looked new, and took a look at the surroundings. The construction company's sign was covered with a creeping coat of moss, suggesting its business wasn't so hot. This neighborhood wasn't able to support its own economy or provide a living to locals, was it? Did that have anything to do with why so many houses were for sale? My wife pointed to a sign of after-school events, wondering if they actually provided children with educational programs at all. Our oldest son, a senior high school student, asked, "Did the developers remodel all of the unsold houses into chicken coops, and start selling free-range ickens?" Forget about this place. The so-called American-style log villas couldn't be anything like the nostalgic log cabins of western film ne that were actually constructed of lumber.

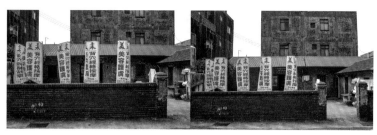

Two red corrugated iron panels leaned against one another over the r
brick parapet on the front and the right side. A red couplet with gold
characters Kung Hei Fat Choy(Wishing you happiness and prosperity
attached to the red wall. Portraits of the God of Wealth are on the colum
The house owner had made use of the opportunity when the village off
was repairing the sewer; he asked the workers to pave a layer of concr
on the ground of his worn-out courtyard. The courtyard looked so fa
now. Congratulations!

On New Year's Eve, children are taught to say Kung Hei Fat Choy. On the first day of the new year, unmarried children come back—Ku
Hei Fat Choy. On the second day of the new year, married daughters return—Kung Hei Fat Choy, the daughter says to her parents. The fi
full moon of the new year, a daughter's future parents-in-law come to have tea with betrothal gifts to the daughter's mom and dad—Ku
Hei Fat Choy. When Dad is napping, Mom quietly changes into a bright red outfit that she just bought with the money in her red envelop
She goes out with a quick pace and passes the white iron water tank, arriving at the newly opened Tender Beauty Shop to use her first V
Certificate for an acupuncture points massage. This massage makes your face and ears feel fresh yet flushed because of the improv
blood circulation. The entire body skin treatment makes you shine radiantly.

Mom is satisfied. Allowing one flag of the beauty shop to be erected in her courtyard, she earned herself one VIP treatment. There are f
more, and she is going to enjoy them all herself.

Two years ago, I came from the windmill country, The Netherlands, to Taiwan. One time I was hang
out with my classmates around nightfall and I saw a store with a sign "Dowry for the Elderly", I said to
classmates teasingly, "In Taiwanese weddings, the bride's dowry is very culturally sophisticated. I had
idea that a dowry would differ for people of different ages!" (My Taiwanese classmates laughed, but th
covered their mouths.) I insisted on taking a look in the store, so they accompanied me. Wow, insid
found so many traditional clothes with bright colors, Chinese patterns and knot buttons all the way up
the neck. I thought to myself how wonderful these were! I could mail several of them to my family ba
home as their Christmas presents. Looking at them closely, they were made of cotton, instead of silk or satin, or leather. The shop own
noticed how infatuated I was, he stood up from his stool and approached me. In a grave tone, he inquired, "You are not buying them
yourself, I suppose?" (I understood this Chinese question.) He unfolded one robe for us, so we could see it closely. Wow, the wide hem a
large bell sleeves were impressive. But, were the sleeves a little bit too long? I also noticed that several clothes under the shelf were se
with a long strip of white cloth. I wanted to ask the owner if it was the latest fashion. (My classmates dared not to translate for me.) The
saw a small sticker with numbers: One=300, Three=750, so I asked him bluntly, "How much do you charge for two? And if one buys four
them, would you offer a bigger discount?"

The owner knotted his eyebrows. He folded the robe and put it back into the shelf. In silence, he sat back on his stool.

*In Chinese societies, "dowry for the elderly" means funerary objects, including shrouds. Funerary objects must be handled in o
numbers, and funeral shrouds are usually in traditional styles and made of cotton. The overly long sleeves are to cover up the decease
hands, to protect his or her offspring in the belief that this helps to prevent them from becoming beggars in the future. Funeral shrouds do
use buttons but are closed by cloth strips which are tied together.*

Ah-Kuan, for quite some time I have gotten into the habit of falling asleep while playing chess in the activity center of our community, so no one wants to play with me any more. I sit in front of the TV, listening to it. I can't hear the sounds from TV clearly, even though it is so loud that the neighbors protest. These days your sister-in-law Ah-Yin's noodle store has quite a good business, and your mother has a job washing dishes every night and comes home very late. The power plant in our neighborhood is still burning heavy oil, and since the 2013 news that it transformed the huge yellow duckling from the Netherlands into a smoked Taiwanese duck, no one needs to ask where the power plant is now.

ng with the oil and smoke for so long, people who had been affected are long gone, those who stayed feel nothing. Do you remember vendor selling almond tea and deep-fried dough sticks? It was so popular that fishermen lined up to buy them. But since a new owner k it over, he only runs the business around nightfall on Saturdays. He simply makes drinks with instant coffee packs made in Thailand n hot water, adding deep-fried dough with a hole in the center. He called it a "donut". And you know, the general store we inherited from ndpa no longer provides fishermen with kimchi, preserved veggies, or ration biscuits. Now I go to the wholesalers in Dihua Street to raffle tickets, bamboo water guns, round game cards, bubble glue, chocolate toothpaste, and toy lipsticks. I mainly sell these things to tomers from Taipei. Yes, I made a temporary parking space in front of the store without a permit from the authorities, and I earn a little bit llowance by charging drivers to park there. Regarding older brother, he is still the same. He often drives a boat out to the high seas and s fuel to fishing boats from China. Last week, a report from the New York Times said the fuel from this kind of trade ended up in North ea, so he was picked up and detained and interrogated. It has been three days now, your sister-in-law is often in tears while she cooks odles, but I don't have money to hire a local government representative to help.

, yes, Ah-Kuan, is the food inside there OK? Do you need your bro to deliver meals for you?

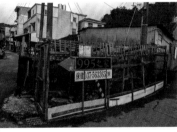

House of 995, homophones of "House of Wine, Wine, and Dance". Is the blue arrow guiding me to a place where I can leave my depression behind? Or, House 995 means you won't spend more than 1,000 bucks? I am so curious. If it is a vitamin store, will they be endorsed by a celebrity? Following the direction of this mysterious sign and climbing up the hill, I wonder if it is connected to the road behind the white apartment. Next time I should find a man to accompany me for an adventure. I drink some water and take a look ahead again. At the intersection of the two roads are two concrete electric poles (one has the words "Zaoqiao Village Office" written on it) and one wooden electric pole. The three poles stitute the border of an irregularly shaped orchard. To my surprise, even though the plants grown inside might not be edible or tasty, a r is erected to protect them. Or, perhaps the door is to block dogs and cats from getting in?
e small orchard is framed by three, long white boards standing on top of drain grates. A black net taller than a person holds up a long row short and faded wooden sticks. These materials must have been found somewhere and then arranged tidily. But the orchard is a mess. rhaps the owner was in a bad mood? Or, is the mess because of an old person's frugality? Looking more carefully, beside the road there s a black tarp. What did it cover? Going across the road there is another very similar orchard on the left side. A red scooter is parked side that one. Had the rider of the scooter parked here and gone to mediate a car accident that had just happened involving a big truck d what appeared to be a small van? Taking my phone out to check the time, I realized it was time to go.

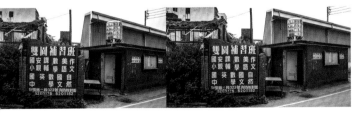

The water tank on the roof of the public restrooms on Paoshan Street had leaked for three days, and no water could be stored. The village office had no time to fix it, so a notice was issued first, "Keep the door to the women's restroom open for better ventilation. Please use it cautiously."
Because pension reform policy was almost a sure thing, a senior firefighter who had served decades knew it was useless to postpone his retirement. On the day his retirement, he and several friends established the first and only cram school in the village, teaching math, science, writing, English and Chinese one-to-one classes. If one reads their signs alternatively, their slogans would become, "Composition Nature", "American Chinese", "Afterschool glish". It looked like they provided unique programs.
llo! Hello! Is this the Fire Department? Please send a firefighter who speaks English. Our foreign teacher is locked in the restroom!"

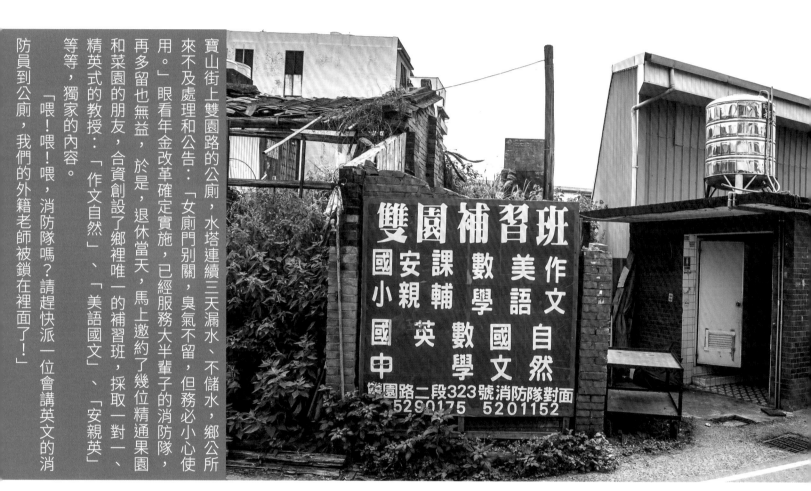

寶山街上雙園路的公廁，水塔連續三天漏水、不儲水，鄉公所來不及處理和公告：「女廁門別關，臭氣不留，但務必小心使用。」眼看年金改革確定實施，已經服務大半輩子的消防隊，再多留也無益，於是，退休當天，馬上邀約了幾位精通果園和菜園的朋友，合資創設了鄉裡唯一的補習班，採取一對一、精英式的教授：「作文自然」、「美語國文」、「安親英」等等，獨家的內容。

「喂！喂！喂，消防隊嗎？請趕快派一位會講英文的消防員到公廁，我們的外籍老師被鎖在裡面了！」

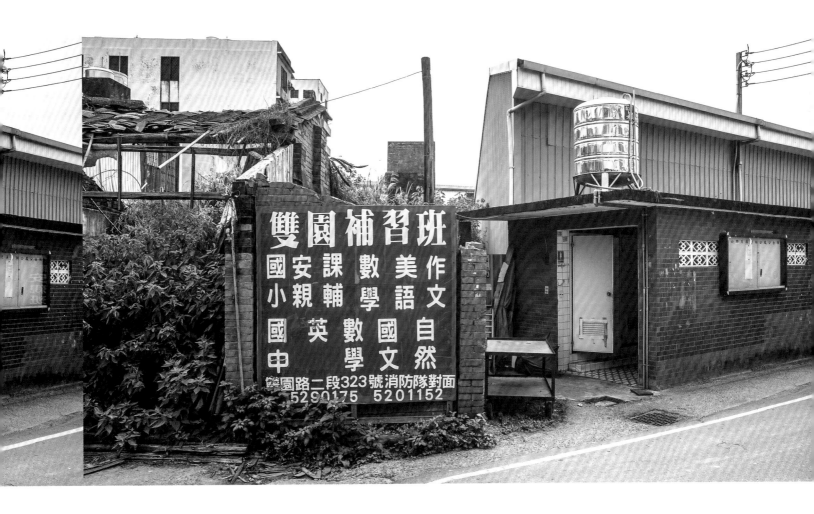

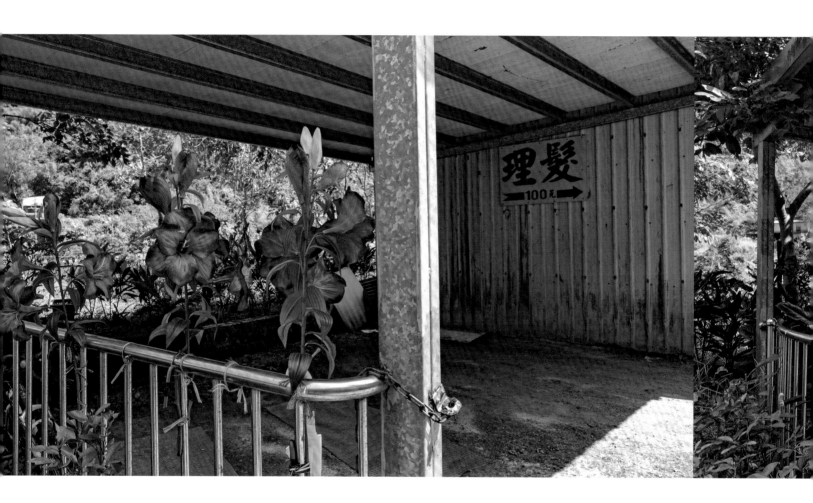

街口第三家，前不久才搬來的新鄰居（聽說是從縣政府違章建築科退休，名字不詳），將石碇公路旁，原本是雜草叢生的小空地，先鋪上水泥，連夜再趁著里長來不及通知管區前，立柱、加蓋，撐起了鐵皮屋頂（厲害！果然是行家）。於是，他那一輛裕隆古董級的老車——勝利，從此不再擔心風吹雨打太陽曬（車棚的另一半邊，還出租給隔壁的小賴）。車棚右半邊的後方，有鐵門的儲藏室上鎖了（內容不詳，有點神秘）。左半邊，三株人造的紫百合，用粉紅色的塑膠繩繫在嶄新不鏽鋼的欄杆上，青雨傘靠在一旁（老男人耍浪漫？×××）。車棚內，牆壁上懸掛著「理髮」的指示牌（冷水洗頭？百塊不找？免費停車嗎？）我看，最好站在門口先問個清楚，免得坐下來後悔來不及。

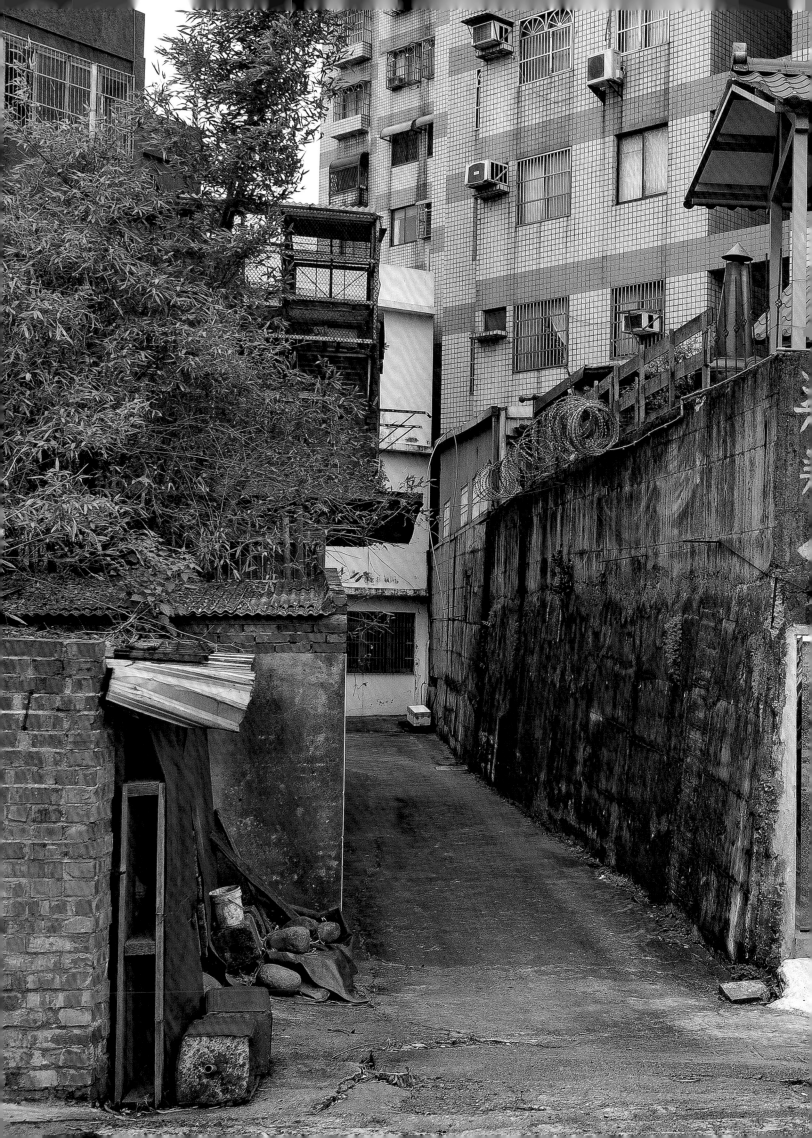

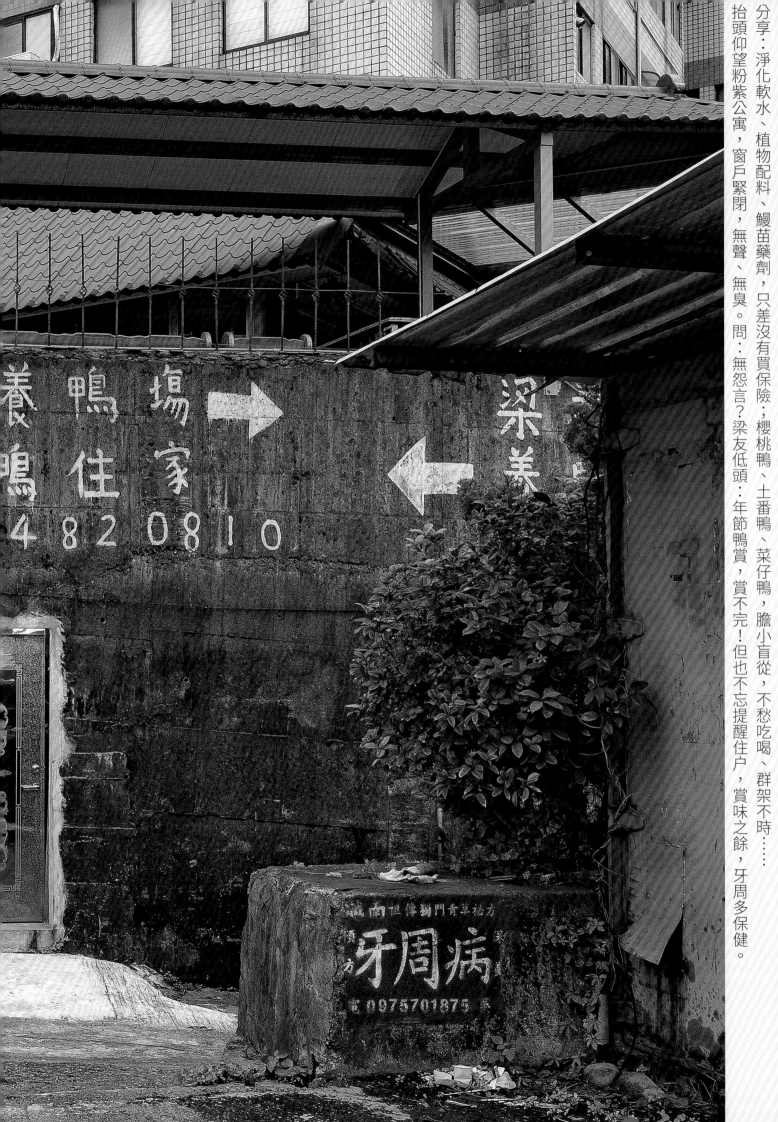

養鴨塢家
鴨住
48 20810

梁養

誠南祖傳獨門青草秘方
牙周病
0975701875

年節將近，專車前往楊梅訪友——養鴨梁達人。早聽地方新聞報導，高欄有電，鐵門上鎖，牆內廣闊，鴨群有休息處，避免整天游泳過勞傷鴨身。梁友進一步分享：淨化軟水、植物配料、鰻苗藥劑，只差沒有買保險，櫻桃鴨、土番鴨、菜仔鴨，膽小盲從，不愁吃喝、群架不時⋯⋯抬頭仰望粉紫公寓，窗戶緊閉，無聲、無臭。問：無怨言？梁友低頭⋯⋯年節鴨賞，賞不完！但也不忘提醒住戶，賞味之餘，牙周多保健。

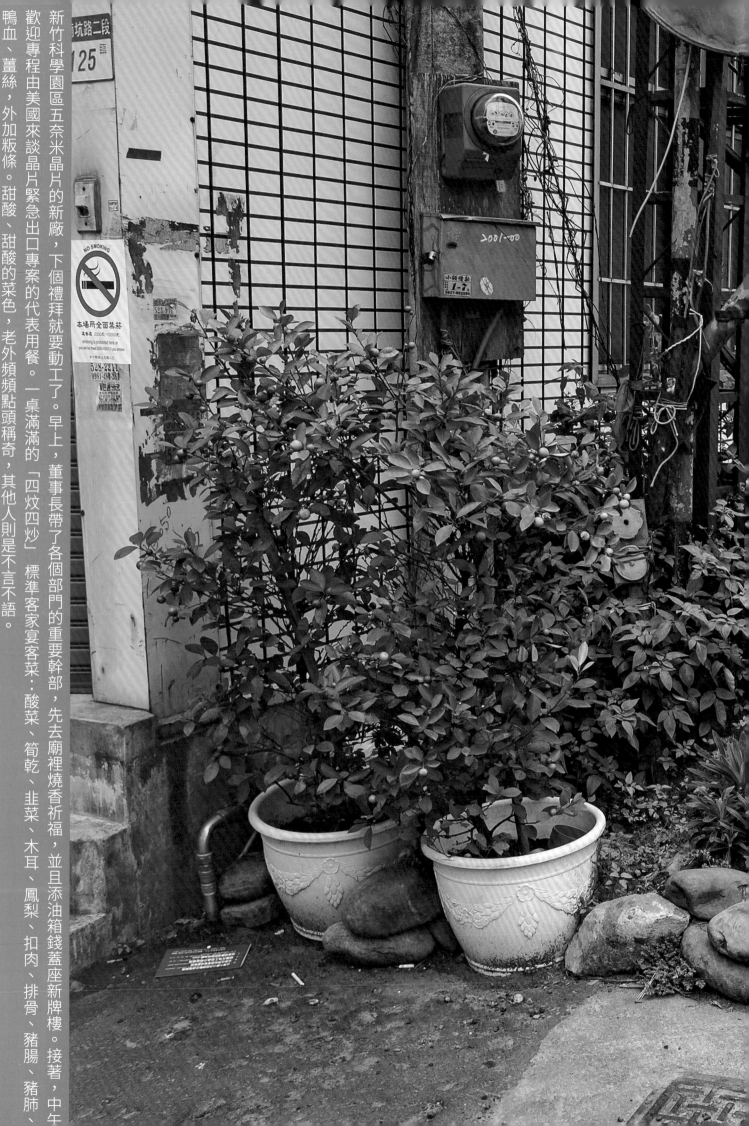

新竹科學園區五奈米晶片的新廠，下個禮拜就要動工了。早上，董事長帶了各個部門的重要幹部，先去廟裡燒香祈福，並且添油箱錢蓋座新牌樓。接著，中午歡迎專程由美國來談晶片緊急出口專案的代表用餐。一桌滿滿的「四炆四炒」標準客家宴客菜：酸菜、筍乾、韭菜、木耳、鳳梨、扣肉、排骨、豬腸、豬肺、鴨血、薑絲，外加粄條。甜酸、甜酸的菜色，老外頻頻點頭稱奇，其他人則是不言不語。

酒過三巡、菜過五味，隔壁桌，公司特約的林會計師突然起身：「沒有吃飽的人，現在跟我去阿婆客家大湯圓！」轟隆、轟隆，圓形鐵椅被移動的聲音，飯桌上很快的只留下老闆和那一個老外。

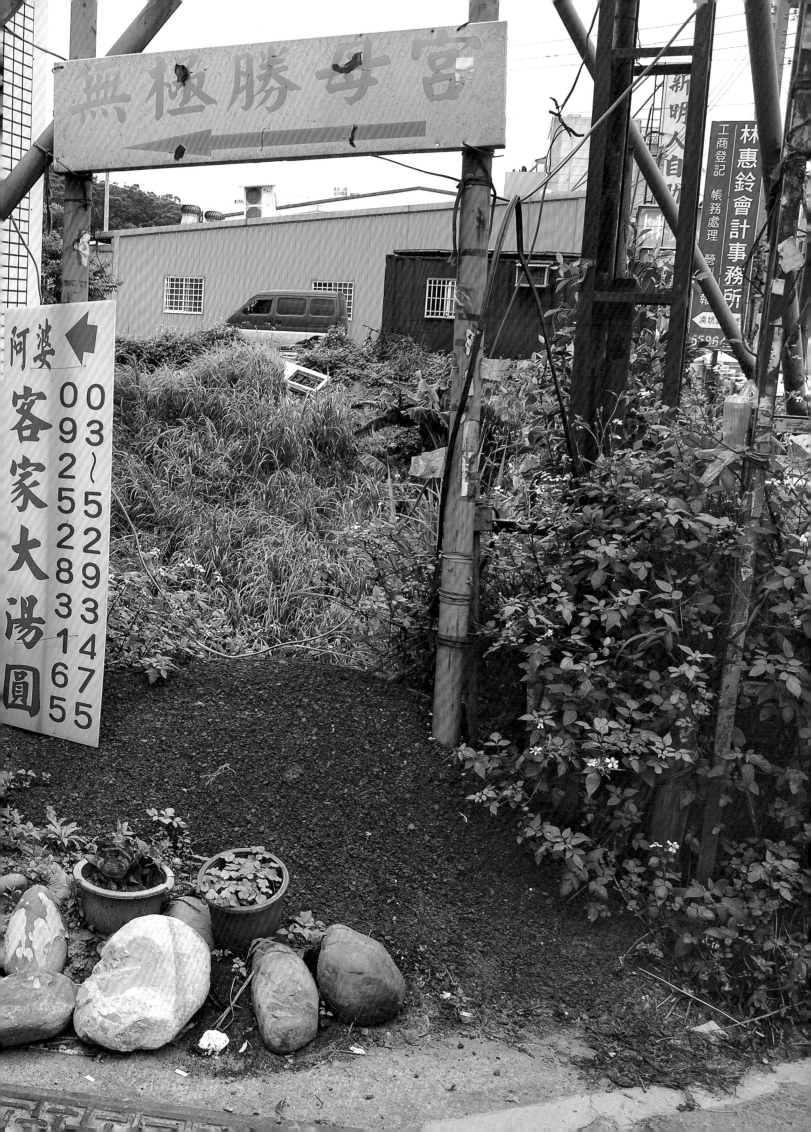

阿嬤駝著背走進來，用滿滿皺紋的手解開自己上衣的第一個扣子，伸進像是口袋的位置，掏出了一小疊皺皺的百元大鈔，說是要替他唯一的小孩買具棺木。我向老婆使了一下眼色，她迅速的拉一把椅子讓老人家坐下，再奉上一杯剛剛泡好的龍眼茶。

阿嬤，邊喝邊喃喃自語：「孩子不是我親生的，但20多年來是我撫養，在校期間都不必我擔心，每學期都拿獎狀回來。」

說著，阿嬤從斜背的黑包包裡，掏出了一疊整整齊齊、同樣大小的獎狀，兩眼茫然：「孩子畢業後，孝順我，不結婚，都是晚上出去工作，隔天早上才回家睡覺，說是夜班的薪水比較高。前天，管區特別開車來載我去基隆省立醫院地下室的停屍間，阿祥如同往常睡覺的樣子，躺在一張灰色的床上，只是我怎麼叫都叫不醒了。」

喝完了杯子裡最後一口的龍眼茶，阿嬤清了一下喉嚨：「今天早上，區公所的小姐到家裡跟我說，已經替我用低收入戶的名義申請到三萬塊，但是絕大部分的錢都先墊給了醫院。」

我，順手翻了一下那一疊，內容完全一樣、影印的獎狀。隔壁寵物店，傳來了一陣陣狗打架的吠叫聲。

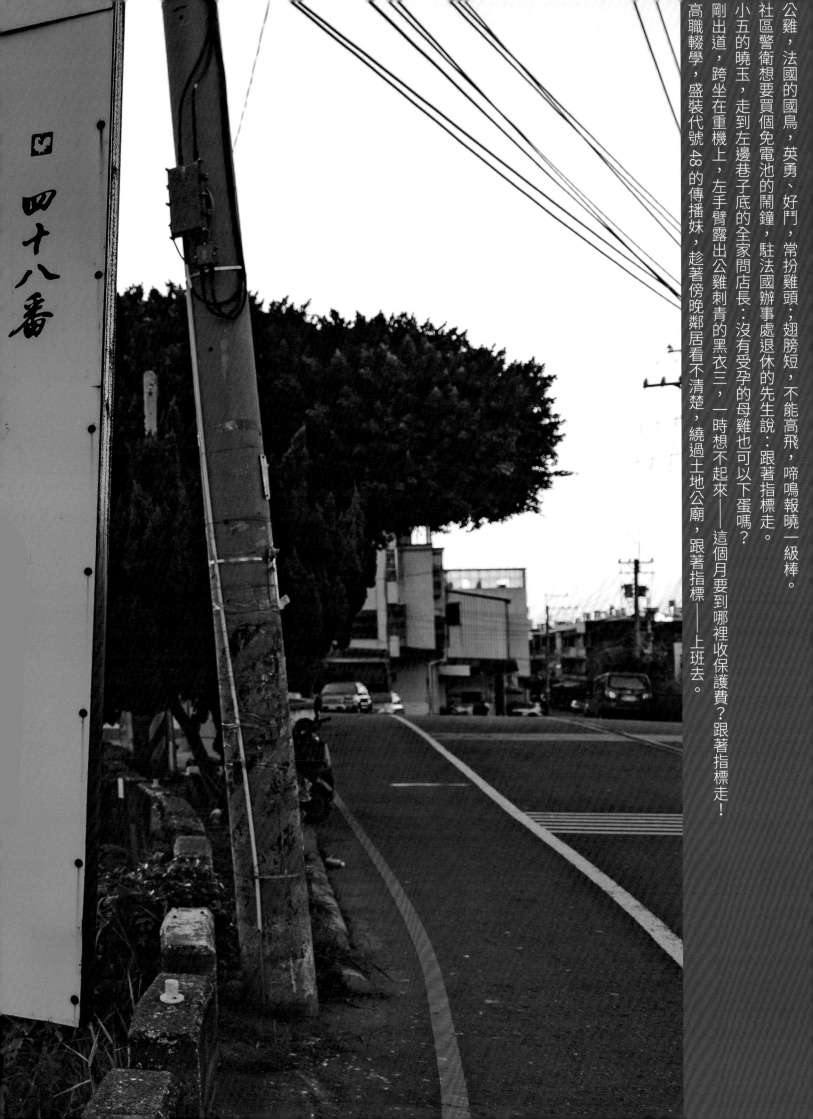

四十八番

公雞，法國的國鳥，英勇、好鬥，常扮雞頭、翅膀短，不能高飛，啼鳴報曉一級棒。

社區警衛想要買個免電池的鬧鐘，駐法國辦事處退休的先生說：跟著指標走。

小五的曉玉，走到左邊巷子底的全家問店長：沒有受孕的母雞也可以下蛋嗎？

剛出道，跨坐在重機上，左手臂露出公雞刺青的黑衣三，一時想不起來——這個月要到哪裡收保護費？跟著指標走！

高職輟學，盛裝代號48的傳播妹，趁著傍晚鄰居看不清楚，繞過土地公廟，跟著指標——上班去。

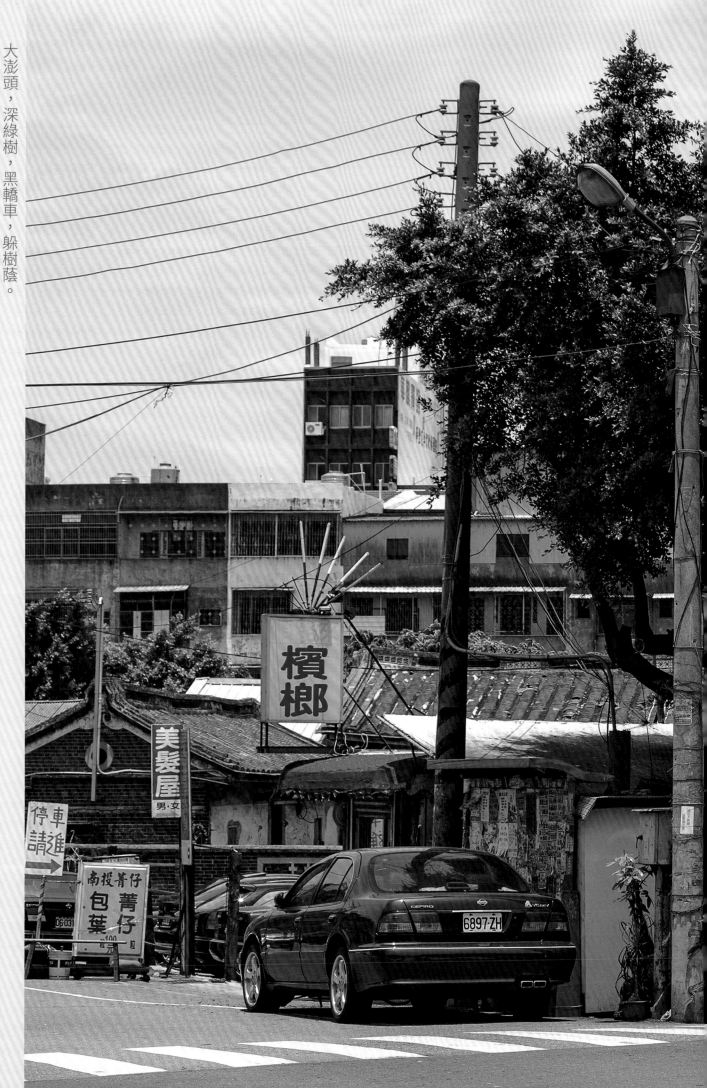

大澎頭，深綠樹，黑轎車，躲樹蔭。

「紙車。金停。買可。紙金。買。可。宅配專線。每。車停可。」

箭頭向左，大馬路微下滑，水泥電線桿旁，公告欄左，無名檳榔店。

「美髮屋，女。男。仔菁投南，菁仔包葉。車。進。停。請。」

箭頭向右。遠遠四樓房，屋頂有水塔。

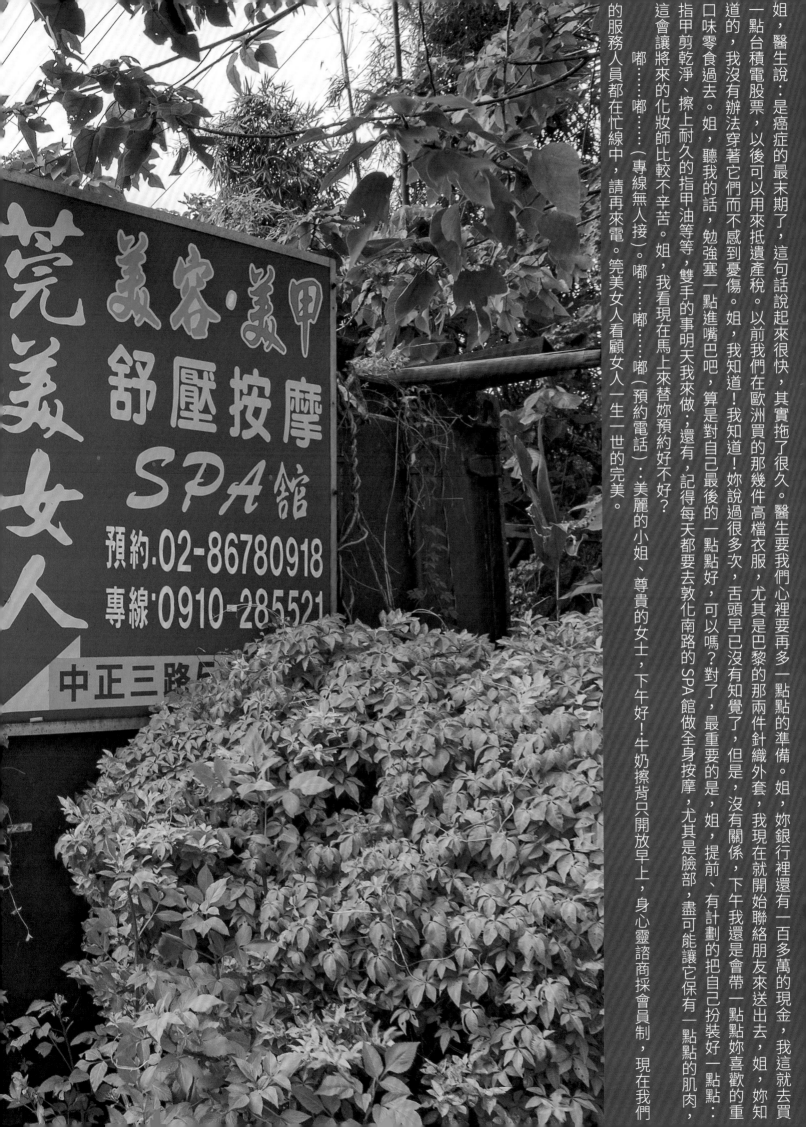

姐，醫生說：是癌症的最末期了，這句話說起來很快，其實拖了很久。醫生要我們心裡要再多一點點的準備。姐，妳銀行裡還有一百多萬的現金，我這就去買一點台積電股票，以後可以用來抵遺產稅。以前我們在歐洲買的那幾件高檔衣服，尤其是巴黎的那兩件針織外套，我現在就開始聯絡朋友來送出去，姐，妳知道的，我沒有辦法穿著它們而不感到憂傷。姐，我知道！我知道！妳說過很多次，舌頭早已沒有知覺了，但是，下午我還是會帶一點點妳喜歡的重口味零食過去。姐，聽我的話，勉強塞一點進嘴巴吧，算是對自己最後的一點點好，可以嗎？對了，最重要的是，姐，提前、有計劃的把自己扮裝好一點點：指甲剪乾淨、擦上耐久的指甲油等等，雙手的事明天我來做；還有，記得每天都要去敦化南路的SPA館做全身按摩，尤其是臉部，盡可能讓它保有一點點的肌肉，這會讓將來的化妝師比較不辛苦。姐，我看現在馬上來替妳預約好不好？

嘟……嘟……嘟……嘟（預約電話）…美麗的小姐、尊貴的女士，下午好！牛奶擦背只開放早上，身心靈諮商採會員制，現在我們的服務人員都在忙線中，請再來電。莞美女人看顧女人一生一世的完美。

嘟……嘟……（專線無人接）。

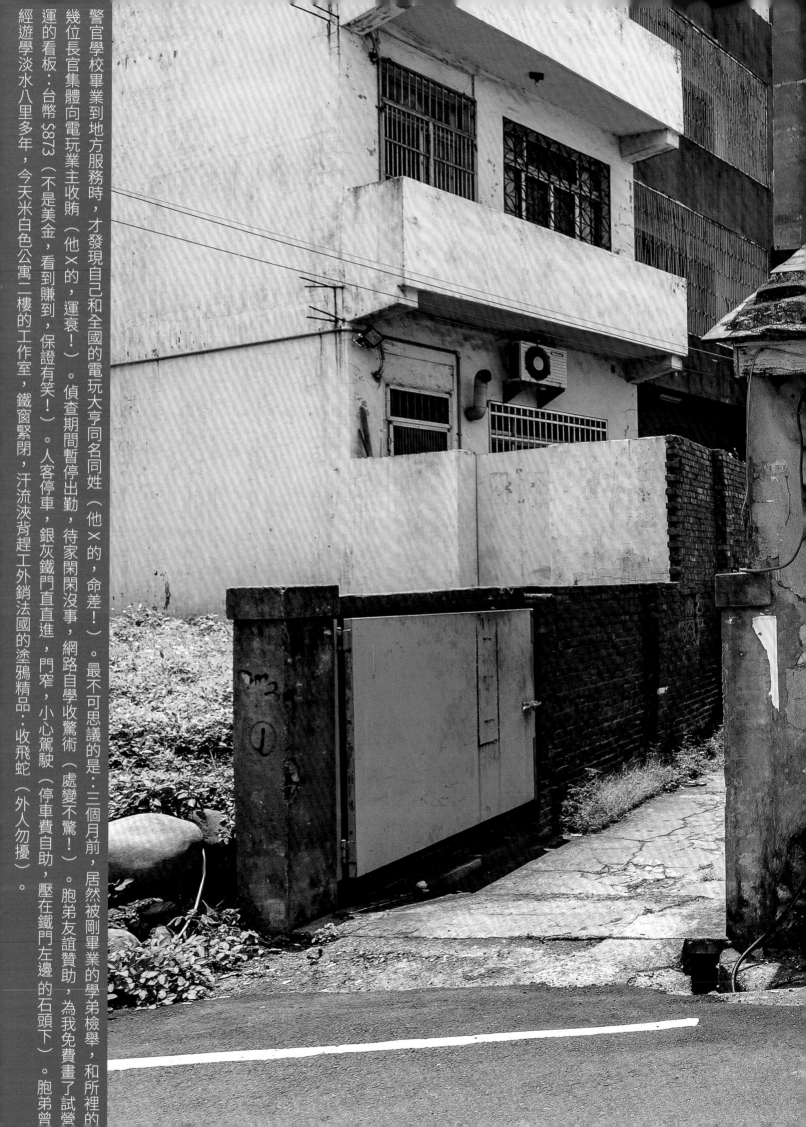

警官學校畢業到地方服務時，才發現自己和全國的電玩大亨同名同姓（他X的，命差！）。最不可思議的是：三個月前，居然被剛畢業的學弟檢舉，和所裡的

幾位長官集體向電玩業主收賄（他X的，運衰！）。偵查期間暫停出勤，待家閒閒沒事，網路自學收驚術（處變不驚！）。胞弟友誼贊助，為我免費畫了試營

運的看板：台幣 $873（不是美金，看到賺到，保證有笑！）。人客停車，銀灰鐵門直直進，門窄，小心駕駛（停車費自助，壓在鐵門左邊的石頭下）。胞弟曾

經遊學淡水八里多年，今天米白色公寓二樓的工作室，鐵窗緊閉，汗流浹背趕工外銷法國的塗鴉精品：收飛蛇（外人勿擾）。

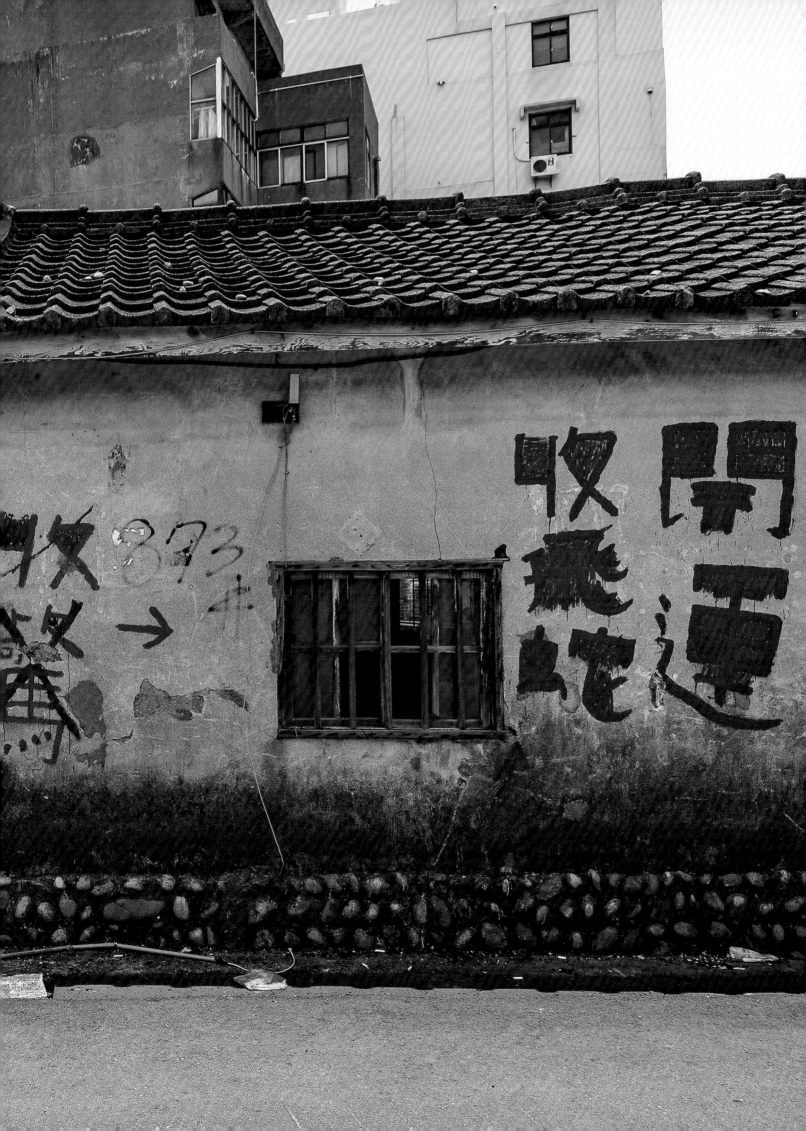

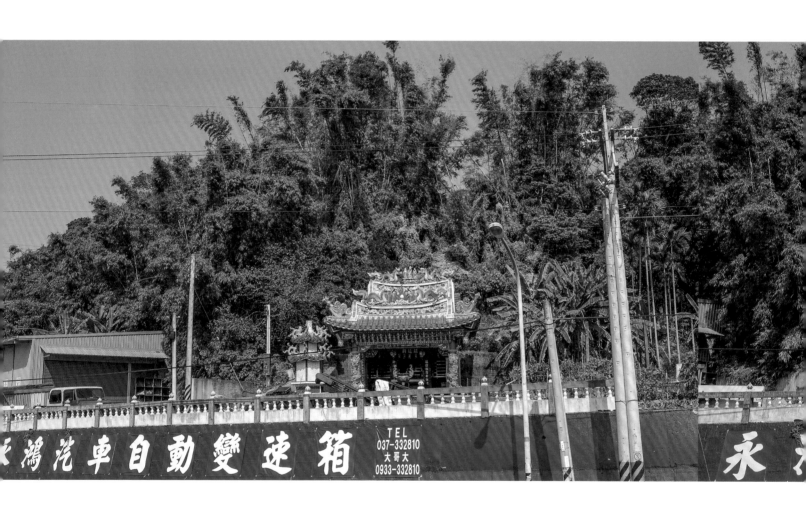

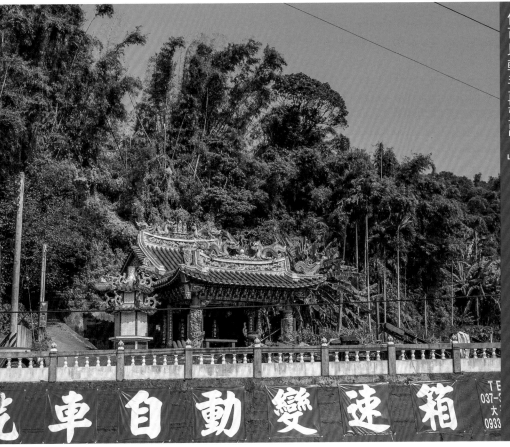

透過 ebay 從關島便宜買到一輛幾乎是全新的吉普車，交車後才發現是手排！心想，應該不會太難！

上網查詢「手排教學」：啟動，排檔放到空擋，踩住煞車，轉動鑰匙，踩住離合器與煞車，右手入一檔，右腳從煞車移到油門，慢慢加油，左腳微微鬆開離合器，感覺車往前傾時，再踩一些油門，離合器放掉些，踩油門，放離合器，加速後踩離合器，放油門，入二檔，再踩油門，放離合器向右入三檔⋯⋯下拉四檔⋯⋯

馬上試車，但是，手排的節奏不對，咚，咚，車子熄火。滿頭大汗，二話不說，走進嶄新的大廟燒香問神明：「多少錢便可以轉手再賣出？」

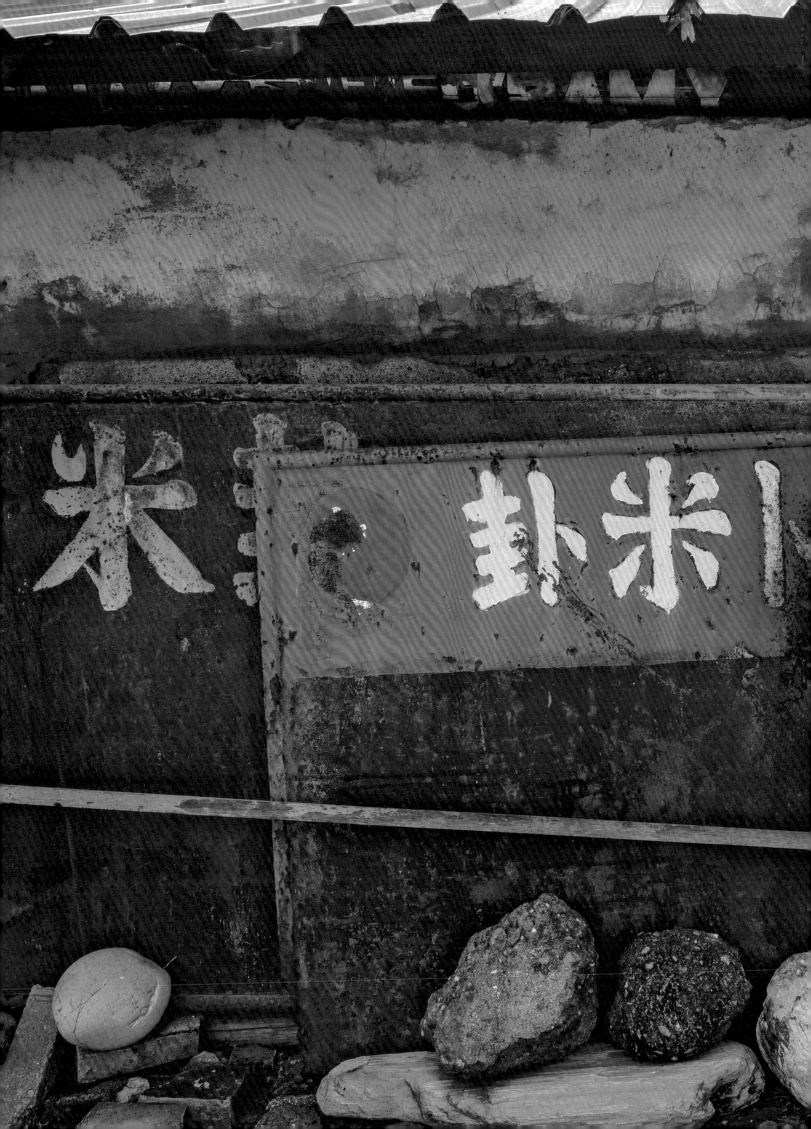

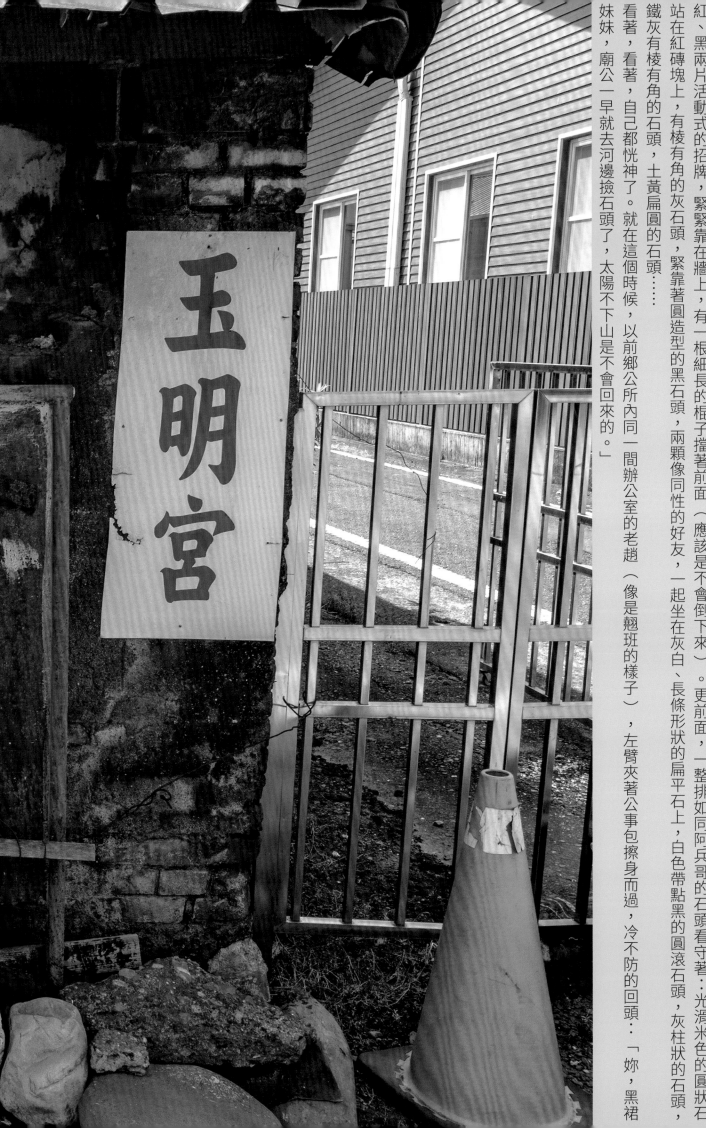

早早就到屏東客運站的檢票口，等了好幾班車，終於看到穿著綠校服套著黑裙的玉明，臉憂憂的下了車。快步走向前問她：「阿公，你是不知道疫情期間，車上不能吃東西嗎？」（如同十多年來的反應，自己趕緊閉上了嘴巴）白球鞋，接著快步的向前，黑布鞋，只能氣喘喘的跟隨在後。我著急的向內大聲呼叫，可惜沒有人回應。只見一旁，站在紅磚塊上，有棱有角的灰石頭，緊靠著圓造型的黑石頭，兩顆像同性的好友，一起坐在灰白、長條形狀的扁平石上，白色帶點黑的圓滾石頭，灰柱狀的石頭，更前面，一整排如同阿兵哥的石頭看守著：光滑米色的圓狀石

早早就到屏東客運站的檢票口，等了好幾班車，終於看到穿著綠校服套著黑裙的玉明，臉憂憂的下了車。「阿公，你是不知道疫情期間，車上不能吃東西嗎？」一路無言。過了長治鄉的百年米店，到了玉明宮的巷子口，嶄新的白鐵欄大門未關，周遭不見一個人影。紅、黑兩片活動式的招牌，緊緊靠在牆上，有一根細長的棍子擋著前面（應該是不會倒下來）。鐵灰有棱有角的石頭，土黃扁圓的石頭……

看著，看著，自己都恍神了。就在這個時候，以前鄉公所內同一間辦公室的老趙（像是翹班的樣子），左臂夾著公事包擦身而過，冷不防的回頭：「妳，黑裙妹妹，廟公一早就去河邊撿石頭了，太陽不下山是不會回來的。」

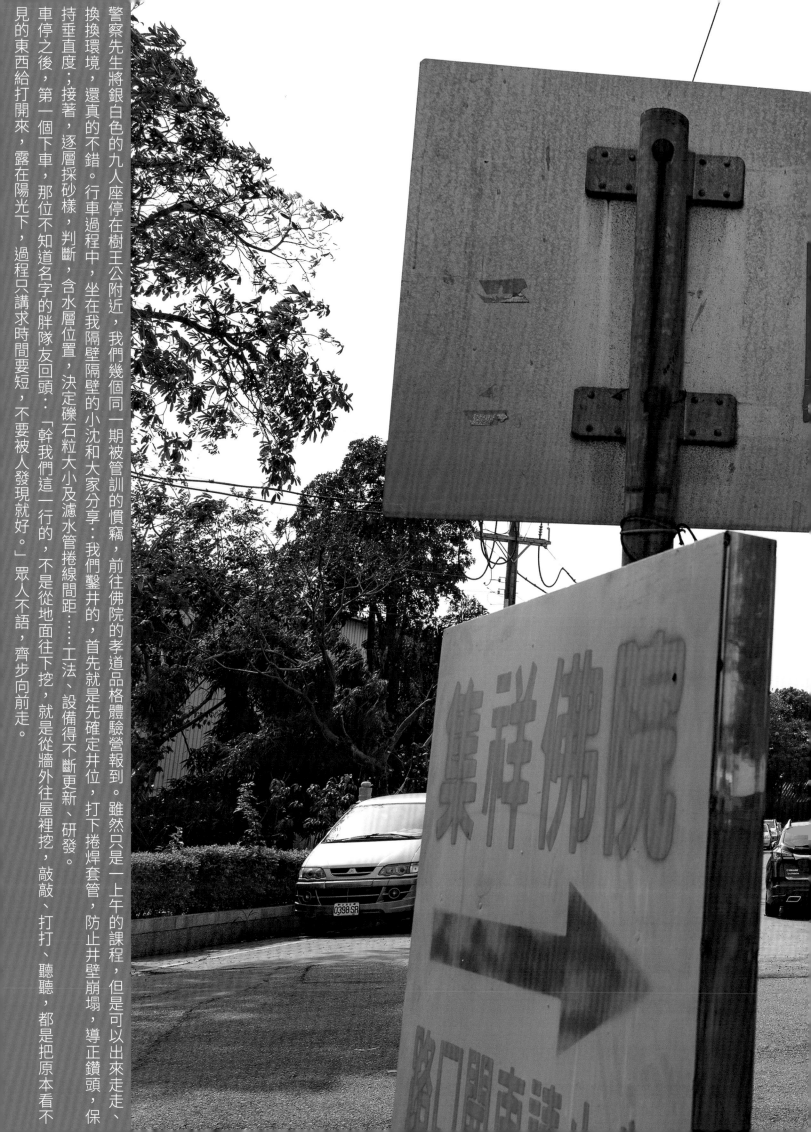

警察先生將銀白色的九人座停在樹王公附近，我們幾個同一期被管訓的慣竊，前往佛院的孝道品格體驗營報到。雖然只是一上午的課程，但是可以出來走走、換換環境，還真的不錯。行車過程中，坐在我隔壁隔壁的小沈和大家分享：我們鑿井的，首先就是先確定井位，打下捲焊套管，防止井壁崩塌，導正鑽頭，保持垂直度…；接著，逐層採砂樣，判斷，含水層位置，決定礫石粒大小及濾水管捲線間距……工法、設備得不斷更新、研發。

持車停之後，第一個下車，那位不知道名字的胖隊友回頭：「幹我們這一行的，不是從地面往下挖，就是從牆外往屋裡挖，敲敲、打打、聽聽，都是把原本看不見的東西給打開來，露在陽光下，過程只講求時間要短，不要被人發現就好。」眾人不語，齊步向前走。

The third household from the entrance of the alley is a new neighbor man said to be a retiree from the County Government's Division Unpermitted Construction, but his name is unknown). He was the m who paved concrete on an empty parcel of land next to the expressw late one night. He also erected columns and added an iron roof bef the neighborhood chief could report it to the local police (indeed, he is expert in illegal construction). So his antique, local brand car, Yulon Cedric, is no longer exposed to storms or the scorching sun(Half of canopy is leased to Little Lai living next door). At the rear of the right, a storage room is locked with an iron door (What is inside? It ma people curious). On the left side, three fake violet lilies are tied to the stainless steel rails with pink plastic ropes. An arctic blue umbr leans against the rail (Is it the romantic element of a retired man?).

The sign "Barber" under the canopy intrigues me (Washing hair with cold water? Haircut 100 bucks? Free parking?) I think I'd better find before going in. Once I sit down in the barber chair, it will be too late.

The New Year was approaching, so I drove to Yangmei to visit a friend, a duck farming expert nam Mr. Liang. I had learned from the local news that his duck farm was protected by an electric fence a locked behind iron doors. Inside the walls was a spacious place where ducks could rest, they would be exhausted by swimming for too long. My friend Mr. Liang explained that their drinking water had be softened, their feed was custom-made, and they were given eel vitamins. Mr. Liang even thought of buy insurance for his ducks. All the Cherry Ducks, Muscovy Ducks, and Tsaiya Ducks were taken good care

Unfortunately these spoiled animals became weak-minded and belligerent, they fought one another from time to time...

Lifting my head to look at the pink tiled apartment building, I noticed all of the windows were tightly closed to maintain a noise-free a odorless environment from their duck-raising neighbor. I asked my friend if he had any regrets. He lowered his head, the smoked du sold during the New Year would be his reward. And, the neighbors were reminded that, after eating the ducks, remember to take care of teeth and gum.

A new 5-nanometer chip plant in the Hsinchu Science Park was to begin construction next week. T morning, the chairman led executives from each division to offer incense at the local temple and don money for the temple's new gate. At noon they set a banquet to greet a trade representative from the for urgent exportation of their products. The table was covered with four stews and four quick fried dish the traditional Hakka feast. There was pickled mustard, dried bamboo shoots, leek, fungus, pineapp braised pork, ribs, pig intestine, pig lungs, duck blood curds, ginger threads, and flat rice noodles. T sweet and sour flavors impressed the foreigner, he nodded all the time, but the others remained silent.

After several rounds of drinking and after all of the dishes were tasted, the company's consulting accountant sitting at the next ta suddenly got on his feet and said, "Follow me to Grandma's Hakka Big Rice Tangyuan if you guys are still hungry. All of them began rumble while moving their iron stools. In a moment, only the chairman and the foreigner were left.

A hunchbacked grandma walked in, she unbuttoned the first button of her shirt with her wrinkled hand, and took out a pile of one hundred bills from her inside pocket. She said she was buying a coffin for her only child. I motioned to my wife, and she quickly pulled a chair over for the old lady to sit. My wife also offered her a cup of longan tea we had just made.

Grandma drank the tea and mumbled, "I didn't give birth to this child, but I raised him for more than twenty years. When he was in school, he was arded certificates of performance every semester." Saying so, Grandma took out a pile of neatly cut papers from the black bag that she re across her body. "After he finished school he decided not to get married in order to take care of me. He worked at night, and came me to sleep the next morning. He said he made more money working the night shift. The day before yesterday a policeman came to take to the Keelung Hospital. At the morgue in the basement, Ah-Hsiang looked like he was asleep on a grey bed. Only I couldn't wake him " Grandma's eyes lost focus.

ping the last longan tea in the cup, Grandma cleared her throat, "This morning, a woman from the district office came to my home and me the office had applied for a thirty thousand dollars subsidiary for a low income household for me. But most of this money had been d to the hospital first."

pped over the pile of papers. They were copies of a certificate of performance with exactly the same content.

that moment, I heard the sound of a dog fight from the pet shop next door.

The rooster is the national bird of France, they are heroic and combative. They have splendid combs and short wings, they can't fly but they loyally crow at the break of dawn.

The community guard wants to buy an alarm clock that doesn't require batteries, so a man who retired from the French Representative Office told him to follow this sign.

Hsiao-Yu, a fifth grader, walked to the Family Mart at the end of the lane on the left side. She asked the guy running the cash register if a hen could lay eggs without conception.

A man who had just joined a gang sat on his motorcycle. The tattoo on his left arm was of a cock. He uldn't remember where to collect the "protection fees" this month, so he decided to follow the sign, too.

. 48 Call Girl, a high school dropout, dressed up and went to work at night, knowing it was a time when her neighbors couldn't see her y well. She bypassed the temple of the land god and followed the sign as well.

A tree's dark green leaves grow like unmanageable hair, providing shade to a black sedan car.

Reading the horizontal sign vertically: "Paper Cars. Golden Parking. Buyable. Paper Gold. Buy. Available. Service Hotline. Every. Parkable."

The arrow points left, the road slightly slopes down. By the concrete electric pole, on the right column of the bulletin, a sign bears only the characters for "Betel Nuts"—a store without a name.

"Hair Salon. Men and Women. Nuts Betel South Toward. Freshly Wrapped Betel Nuts. Car. Enter. Park. Please. " The arrow points right, to a 4 story building off in the distance with a water tower on the roof.

Sis, the doctor said, your cancer is terminal. It sounds fast, but it could drag on for a long time. Doc wants us to be prepared for it. Sis, you still have more than one million dollars cash in the bank, I can u it to buy some stocks of TSMC, it can be used for the deduction of estate tax. And the high-end outfits bought in Europe, especially the two knit jackets we purchased in Paris, I can start contacting our frien and give them as gifts. Sis, you know, I can't wear them without feeling sad. Sis, I know, I know. You told me many times that your tongue had lost its sense of taste a long time ago. But it doesn't matter. T afternoon I will bring you some snacks with strong flavors that you like. Eat them more or less as a tre for yourself, OK? Oh, it is very important, sis, to make yourself up little by little. Have your fingernails manicured and polished. I will do for you tomorrow. And, go to the spa on Dunhua S. Rd. every day to have a full body massage. Especially get your face massaged so y won't lose your facial muscles. It will be easier for the beautician to put makeup on you when the day comes. Sis, let me make the massa appointment for you, alright?

Ddu-du (No answer). Ddu-du, Dud-du(Appointment Hotline): Beautiful ladies and honorable madams, good afternoon. Milk Massage of Back is only provided in the morning. Spiritual & Body Consulting is provided to members only. All of the service staff are busy at t moment, please call back later. Perfect Women take care of the perfect lives of women.

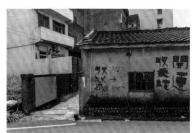

I served my duty in a rural area after graduating from the police college and found out that my name exactly the same as that of a video game tycoon (Fxck, bad omen!). But what was most unlucky wa three months ago, a junior who had just left college reported that I and several officers of our precinct to bribes from video game store owners (Fxck, bad luck!) I was suspended during the investigation, and w nothing to do, I studied exorcism from the Internet (Stay calm and move on). My brother volunteered paint a sign for my trial service period. The fee during the trial service is NTD873(Not USD, very good de for people having the luck to hire me). A customer carefully drove his car through the iron gray door in the very narrow lane(Leave the parking fee under the stone at the left side of the iron gate). My brother had traveled and studied in Bali a Danshui for many years, and today he was working in the studio on the second floor of a milky white apartment. The windows were close and covered in perspiration he was painting the delicate curios to be exported to France: Catching Flying Snakes (Outsiders do not distur

* *"Flying snakes" are herpes zoster(shingles), this is a term used by folk healers to refer to shingles.*

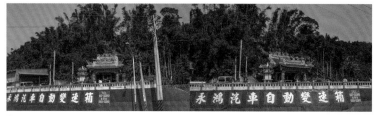

I purchased an almost brand new jeep from Guam via eBay at a ve affordable price, but after the vehicle was delivered, I realized it had manual gear shift.
I had to look online to learn how to operate it: turn on the engine, put gear in N, hold your brakes and slowly turn your key. Step on the clut and brakes, shift to the first gear with the right hand, move your right fo from the brakes to the accelerator and slowly release the gas pedal. Slowly release the clutch from your left foot and when the car sligh leans forward, add more fuel by stepping on the accelerator further. Release clutch further, and accelerate further, release clutch, step clutch after the car accelerates, release accelerator, shift to the 2nd gear, step on accelerator, release clutch, shift the gear to right for t 3rd gear… pull it down for the 4th gear…
I tested my driving right away but couldn't catch the timing. Peng! Peng! The car died. I was sweating profusely, so I immediately decided enter the new temple to offer incense and ask the god, "How much should I resell this car for?"

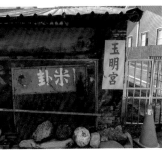

I went to the ticket gate of the Pingtung Bus Station in the early morning to wait. Many buses had passed before Yu-Ming showed up with a green uniform and black skirt. She looked worried. I walked toward her quickly, inquiring, "Did you have some food on the bus?"

"Grandpa, you are not allowed to eat on the bus during the pandemic, don't you know?"

(I shut up. It has been my standard response to asking the wrong questions.) Yu-Ming walked fast ahead in white sneakers, and I followed as fast as I could with my black sneakers, panting. We walked without exchanging words, and when we passed the century-old rice store in Changzhi Village, near the alley of the Yu Ming Temple, the brand new white iron gate was not closed, and not a single soul was around. iously, I shouted toward it, but no one responded. By the gate, moveable black and red signs leaned against the wall, a thin stick ked them from falling (probably unnecessary). In front of them were a row of stones, aligned like soldiers on guard. The smooth milky e sat on a red brick, and an angular grey rock stayed close to a black round rock, like two good friends sitting on a white-grey stone together. There was also a white round stone with black dots, a grey cylindrical stone, an angular iron-grey stone, and a brown-yellow round stone.

king at them, my mind drifted away. At that moment, Old Chao, my colleague from the village office where we had worked in the past, ked by (He probably ditched his work) with his briefcase under his left arm. Unexpectedly, he turned toward us, "Hey, you, little girl with black skirt. The temple deacon has gone to the river to pick up stones. He went in the early morning, and won't be back until sunset."

The policemen parked a silver 9-seater van near the Tree King, and we, convicted hardened thieves, got out and reported to the Camp of Filial Piety and Virtue organized by a Buddhist School. It was a program for the entire morning, but we were allowed to take a walk and get some air. Not bad. During the ride, Little Shen sitting next to me told us of his experience in well drilling: first, locating where to drill, then hammering down the coil welded sleeve pipe. In order to avoid the collapse of the well wall, the driller must be precisely vertical. The next steps were to collect soil samples layer by layer to judge where the water was, and to analyze the size of the gravel, as well as the distances between the filtering tubes. nstruction methods and instruments had to be updated and developed from time to time.

er the van stopped, the weighty man who got out first turned his head, "In our business, we either dig down in the ground or dig into walls of houses. Knocking, hammering, listening; our purpose is to disclose unseen things to the light of day. What matters is time, rything must be very quick to avoid being found out." All the others walked forward without a word.

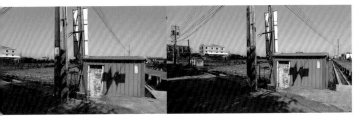

When the weather was good, I went in search of the address my child had written down a half year ago. I parked my car by a ditch next to some dry farmland. There was a row of large trees on the left, and a small olive green iron hut with a red frame and a light blue door on the right. I thought that with an obvious landmark, I wouldn't forget where I'd parked. I was going to try my luck, perhaps I would get business today and make up for losses during the pandemic days of shelter-in-place. In the shadow of a tree, an old man was drinking tea and listening to the radio. lifted his head and took a look at the painted advertisement on my car, speaking absentmindedly (mumbling to himself, perhaps), "Not cessarily find water, right?" From the radio came the news about the pandemic.

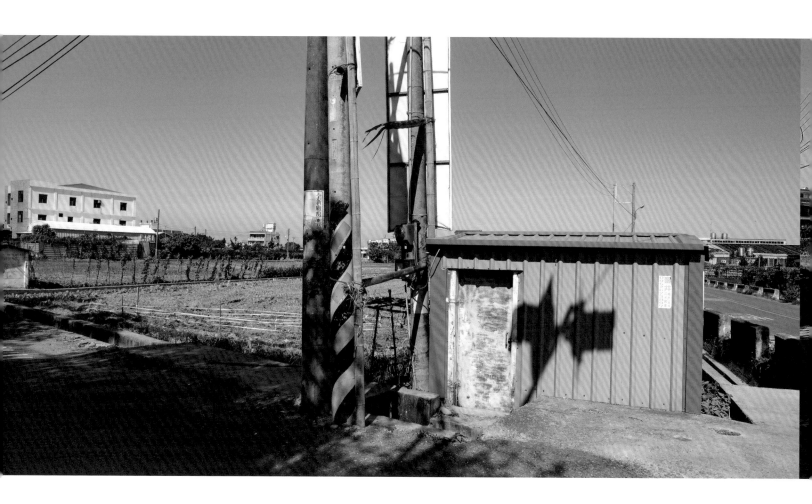

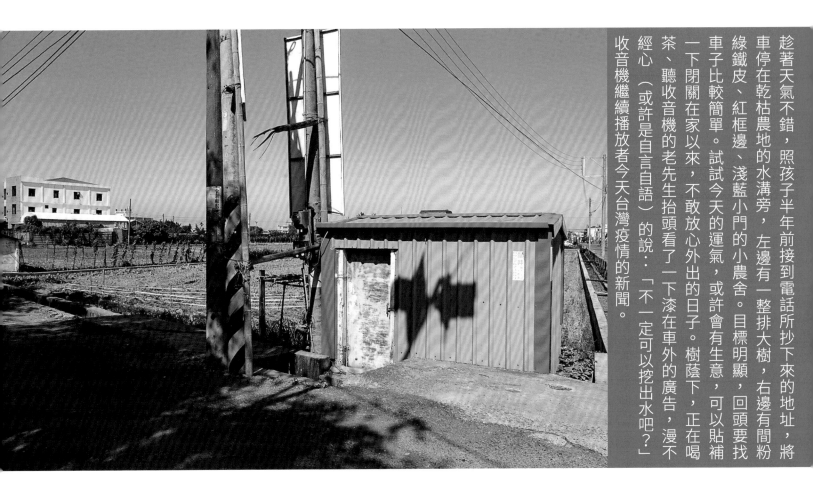

趁著天氣不錯，照孩子半年前接到電話所抄下來的地址，將車停在乾枯農地的水溝旁，左邊有一整排大樹，右邊有間粉綠鐵皮、紅框邊、淺藍小門的小農舍。目標明顯，回頭要找車子比較簡單。試試今天的運氣，或許會有生意，可以貼補一下閉關在家以來，不敢放心外出的日子。樹蔭下，正在喝茶、聽收音機的老先生抬頭看了一下漆在車外的廣告，漫不經心（或許是自言自語）的說：「不一定可以挖出水吧？」收音機繼續播放者今天台灣疫情的新聞。

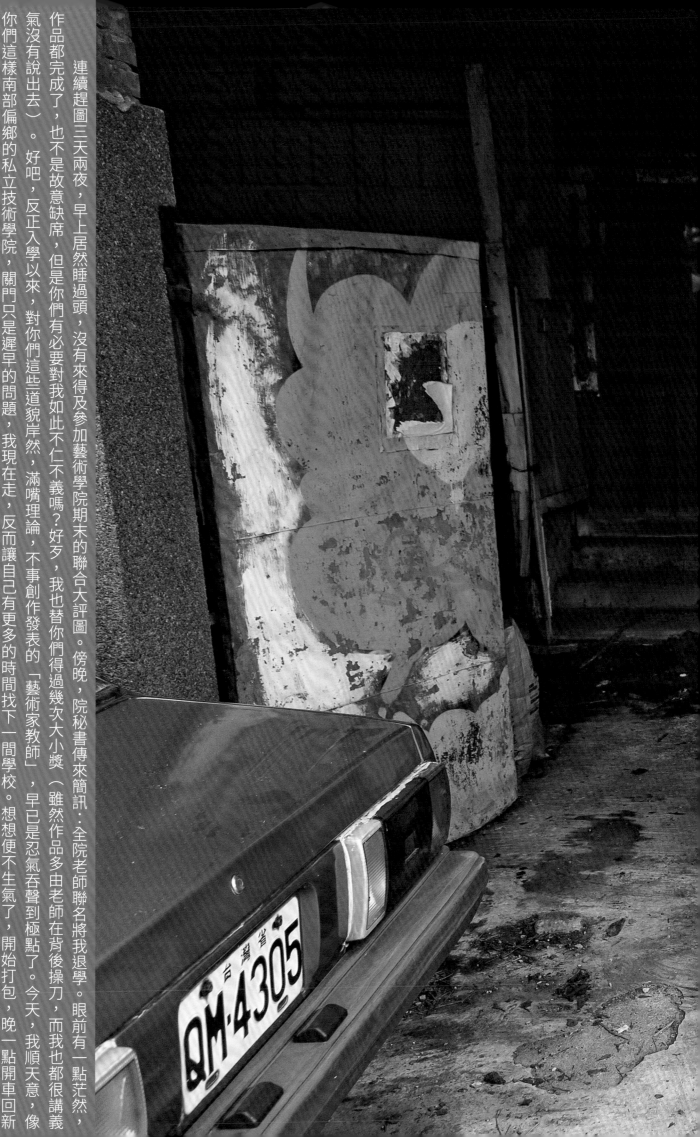

連續趕圖三天兩夜，早上居然睡過頭，沒有來得及參加藝術學院期末的聯合大評圖。傍晚，院秘書傳來簡訊：全院老師聯名將我退學。眼前有一點茫然，

作品都完成了，也不是故意缺席，但是你們有必要對我如此不仁不義嗎？好歹，我也替你們得過幾次大小獎（雖然作品多由老師在背後操刀，而我也都很講義

氣沒有說出去）。好吧，反正入學以來，對你們這些道貌岸然，滿嘴理論，不事創作發表的「藝術家教師」，早已是忍氣吞聲到極點了。今天，我順天意，像

你們這樣南部偏鄉的私立技術學院，關門只是遲早的問題，我現在走，反而讓自己有更多的時間找下一間學校。想想便不生氣了，開始打包，晚一點開車回新

莊老家，吃父母。

對了！我的竹山畫室還沒有到期，趕緊坐下來，打開筆電，在臉書上貼出租訊息試試運氣：「藝術氣質套房要出租，含水電，每月兩千有找，可淋浴，

無廁所（有需要請到黃牆綠叢附近，方便後無需清潔，真正方便！）。綠色帆布請勿翻動或丟棄。有意者，無需預約，跟著地址自行進入參觀（電火開關在樓

梯間左邊的牆上），離開時，請千萬記得順手關燈（夏天電費特別高）。　謝謝！

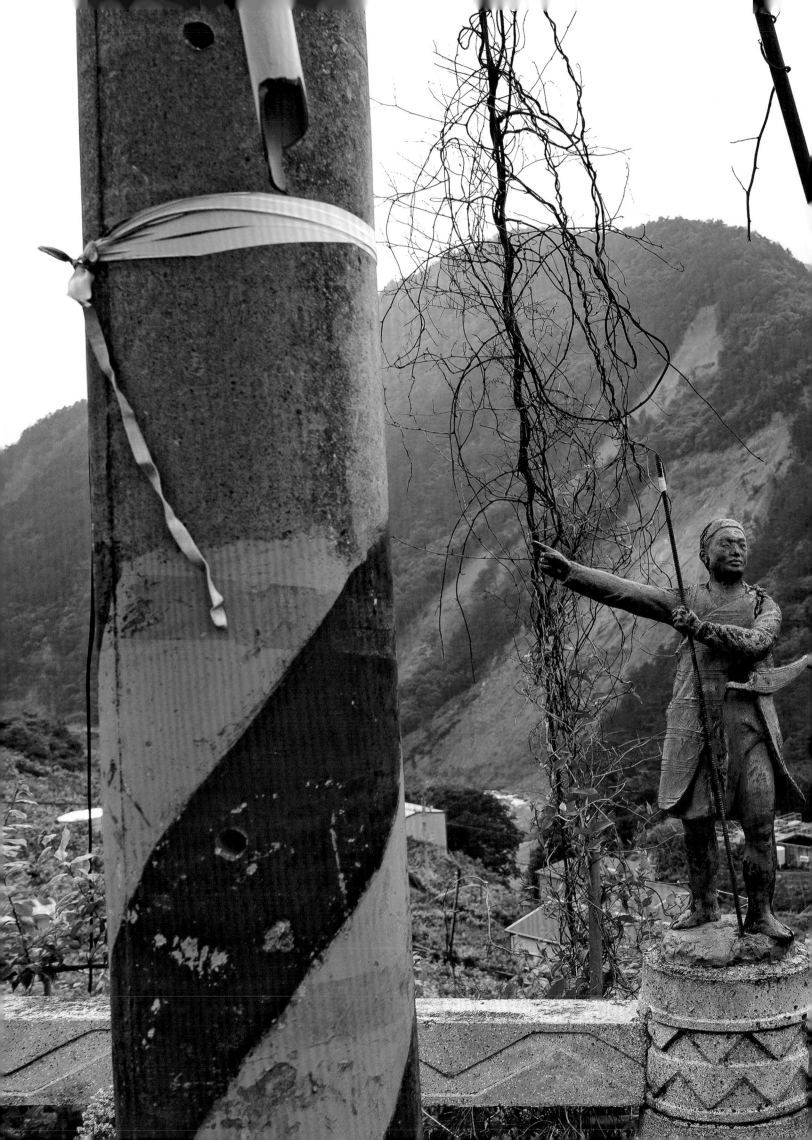

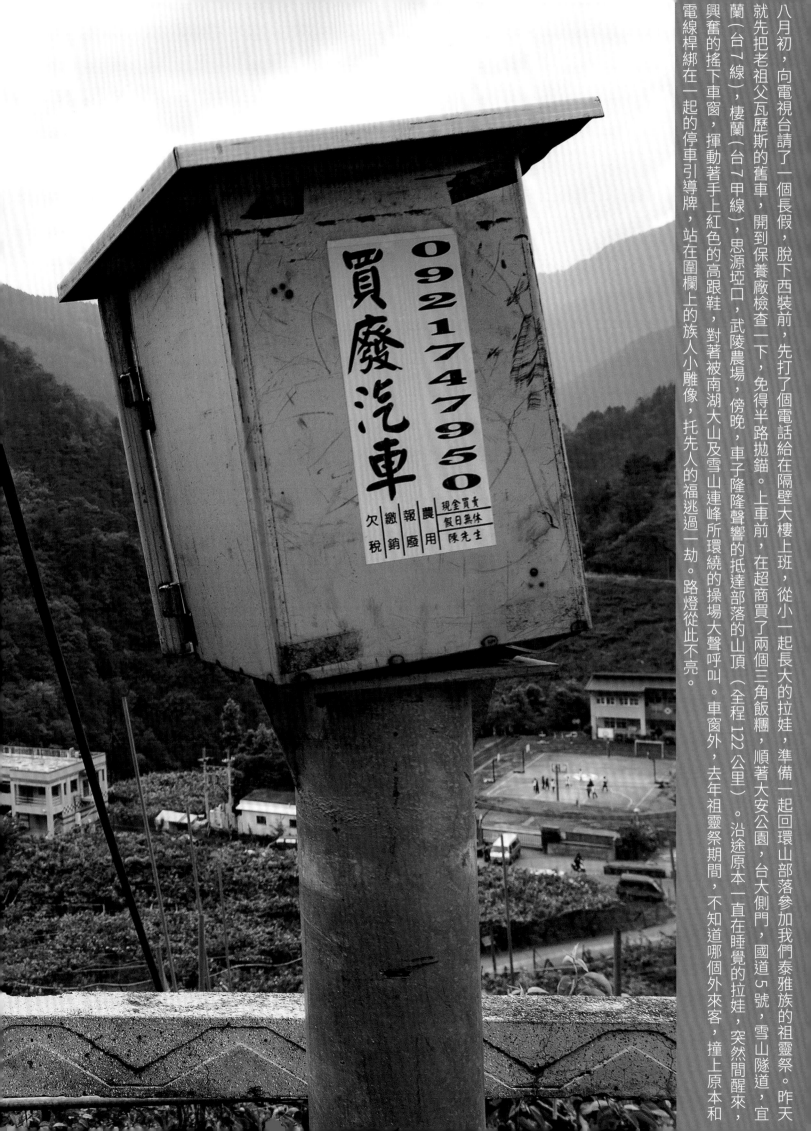

買廢汽車
0921747950

欠繳稅	報銷	農用	現金買賣
			假日無休
			陳先生

八月初，向電視台請了一個長假，脫下西裝前，先打了個電話給在隔壁大樓上班，從小一起長大的拉娃，準備一起回環山部落參加我們泰雅族的祖靈祭。昨天就先把老祖父瓦歷斯的舊車，開到保養廠檢查一下，免得半路拋錨。上車前，在超商買了兩個三角飯糰，順著大安公園，台大側門，國道5號，雪山隧道，宜蘭（台7線），棲蘭（台7甲線），思源埡口，武陵農場，傍晚，車子隆隆聲響的抵達部落的山頂（全程122公里）。沿途原本一直在睡覺的拉娃，突然間醒來，興奮的搖下車窗，揮動著手上紅色的高跟鞋，對著被南湖大山及雪山連峰所環繞的操場大聲呼叫。車窗外，去年祖靈祭期間，不知道哪個外來客，撞上原本和電線桿綁在一起的停車引導牌，站在圍欄上的族人小雕像，托先人的福逃過一劫。路燈從此不亮。

坐在老爸靈車的前座，沿著中潭公路緩緩的開向火葬場，淚水朦朧間，路旁大大的「飯」招牌擦身而過。眼前浮現：國中一年級，為了吃飯的時候，因為老爸不允

許我喝珍珠奶茶，兩天不和您說話；成功嶺第一次放假回家，老爸興高采烈，帶全家頂著大太陽到深坑吃紅燒臭豆腐，當天和四五個大聲嚷嚷的陸客在一張邋遢、

暖棕色的餐桌上共桌，那頓飯，您一句話都沒有說。老爸，我一直不敢跟您說：去年太太如懿和我吵架之後就離家至今。自己煮飯給兩個孩子吃的時候才知道：自

助餐店只供應中晚餐，就是不賣早飯；所謂的「紅燒」是用醬油煮出來的，既不是紅色、也不辣，很多餐廳只賣白飯，不供應我兒子最喜歡的炒麵。前晚，國小五

年級的小女兒吸著青草茶，皺著眉，幽幽地說：「帶一點點苦，很有失戀的滋味。」下午出發前，隔壁的里長大媽拿了一瓶青草茶給我：「不是脾氣大的時候才喝。」

靈車前進了100公尺，正在通過飯店門口，轉個身向後：老爸，您現在餓了嗎？

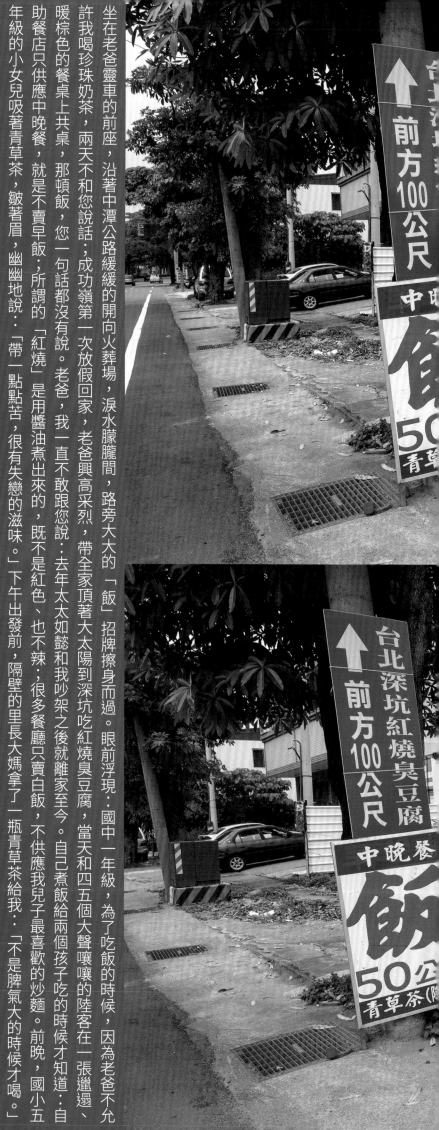

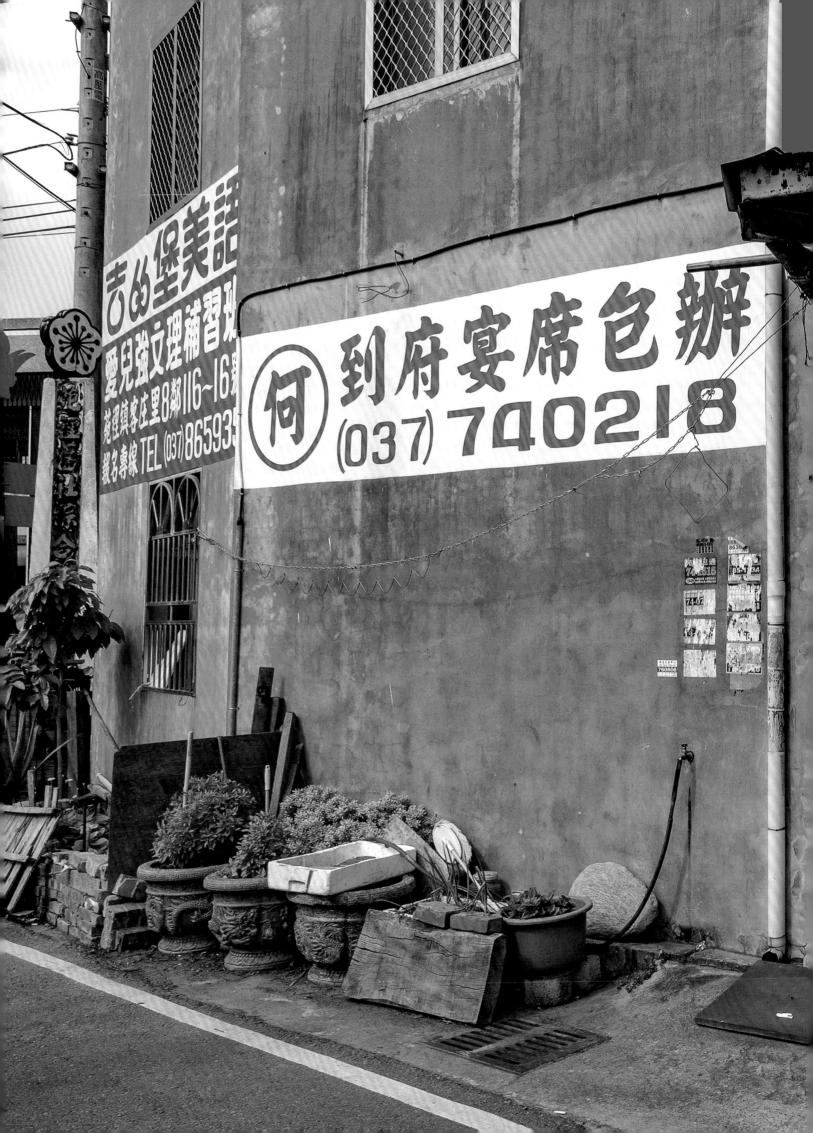

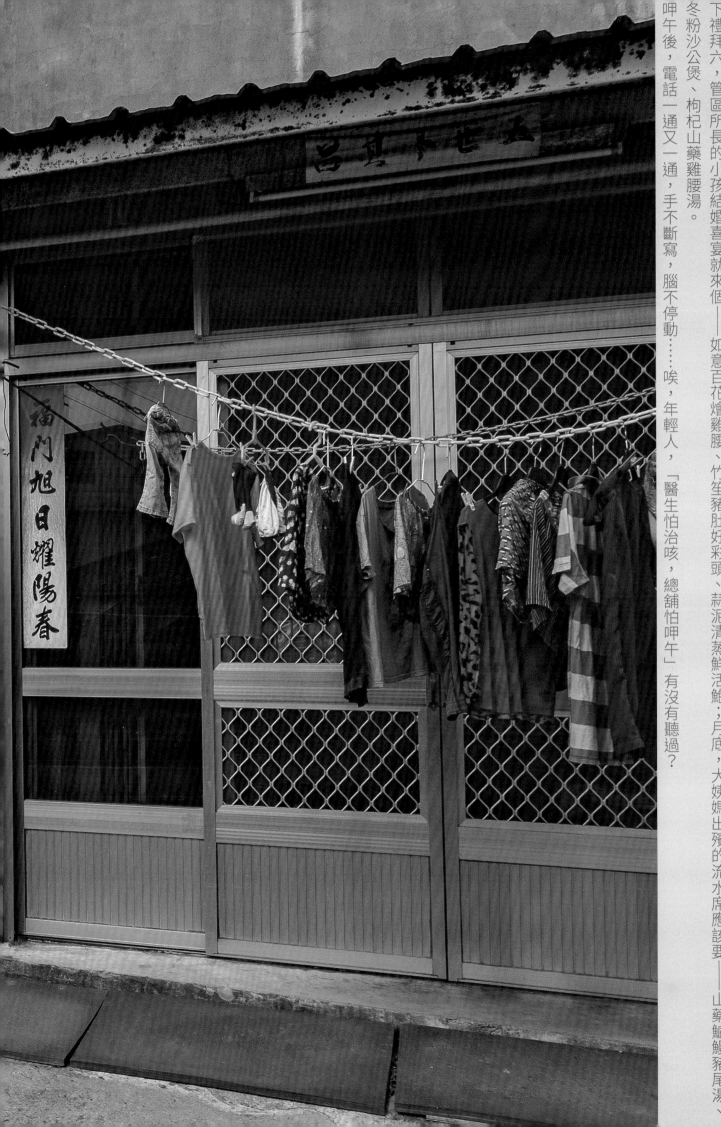

早上，開著採買車從大門直接倒車進廚房後，牽著小孫女兒低頭通過晾曬在家門前的衣服，一起去學美語。我坐教室最後面，一個單字的學，希望將來可以寫出自己的英文菜單。中午過後，按例在大廳接電話：無菜單料理的家庭聚餐、員工宴席、客製的澎湃辦桌……想：前天，里長伯的宮廟神明生日慶典出的菜色是——浦燒鰻米糕、蒜泥鮮蝦米苔目、海鮮錦繡佛跳牆；昨天，四哥拜把的節慶拜拜菜色是——圓滿開運大三拼、鴻運糖醋鮮魚、迎春白菜鮮菇雞；下禮拜六，管區所長的小孩結婚喜宴就來個——如意百花燴雞腰、竹笙豬肚好彩頭、蒜泥清蒸鮮活鮑；月底，大姨媽出殯的流水席應該要——山藥鱸鰻豬尾湯、冬粉沙公煲、枸杞山藥雞腰湯。

電話一通又一通，手不斷寫，腦不停動……唉，年輕人，「醫生怕治咳，總舖怕呷午」有沒有聽過？

呷午後，

兩老旅歐，廣場餵鴿，其樂融融。返國後，念茲在茲。今春，兩老同遊台南，安平古堡處巧見「掛環中心」，進門問養鴿。店裡的小弟笑著說：「伯父、伯母要詢問怎麼養賽鴿嗎？幼鴿出殼，勿提早配對，五天套環（如同人的身分證，過期不補，沒身分就不能參賽），外徑不過 7.5mm，內套保持乾淨不變形，注意——沙、糞不要卡套，否則容易感染細菌。至於種鴿的問題便很專業了：環境佳、打疫苗、營養好。切記訓練時間過長，傷鴿，還要小心，練習的時候可能會隨著其他的鴿群不回自家棚了。」「老爸，等一下，我看就不要吃鱔魚麵了，改去百貨公司頂樓，台南唯一像樣的法國餐廳吃乳鴿吧！」

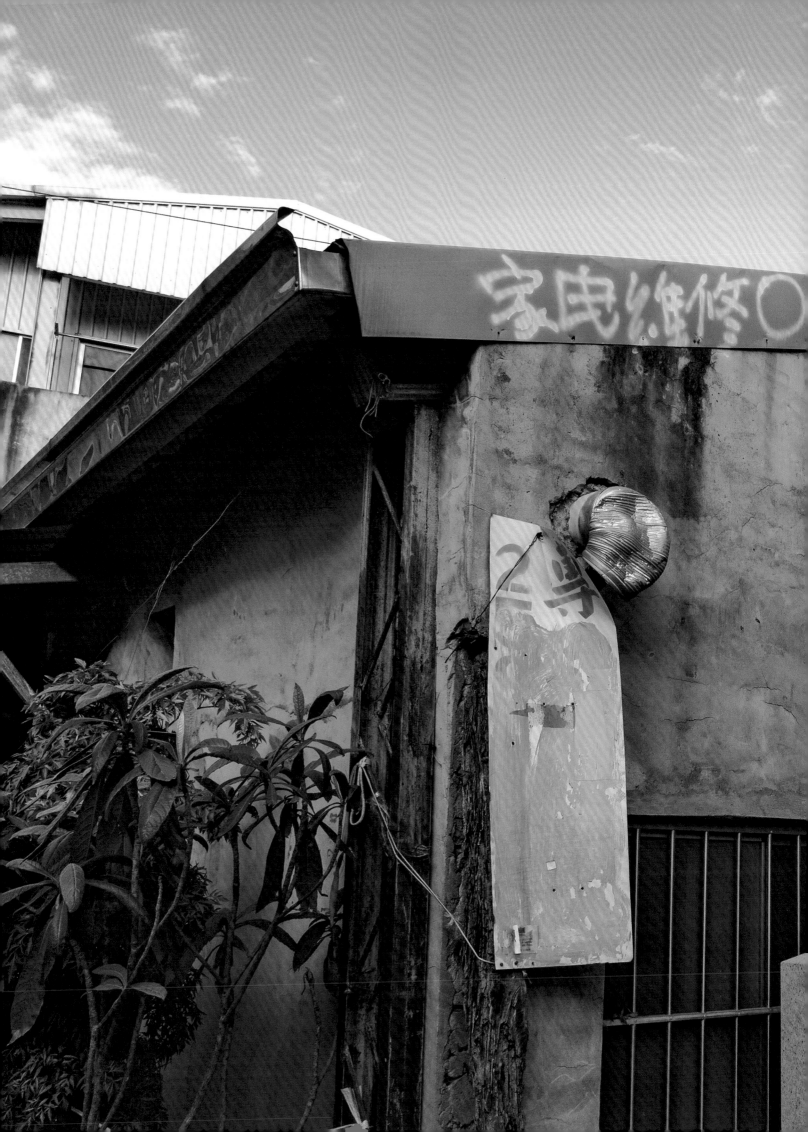

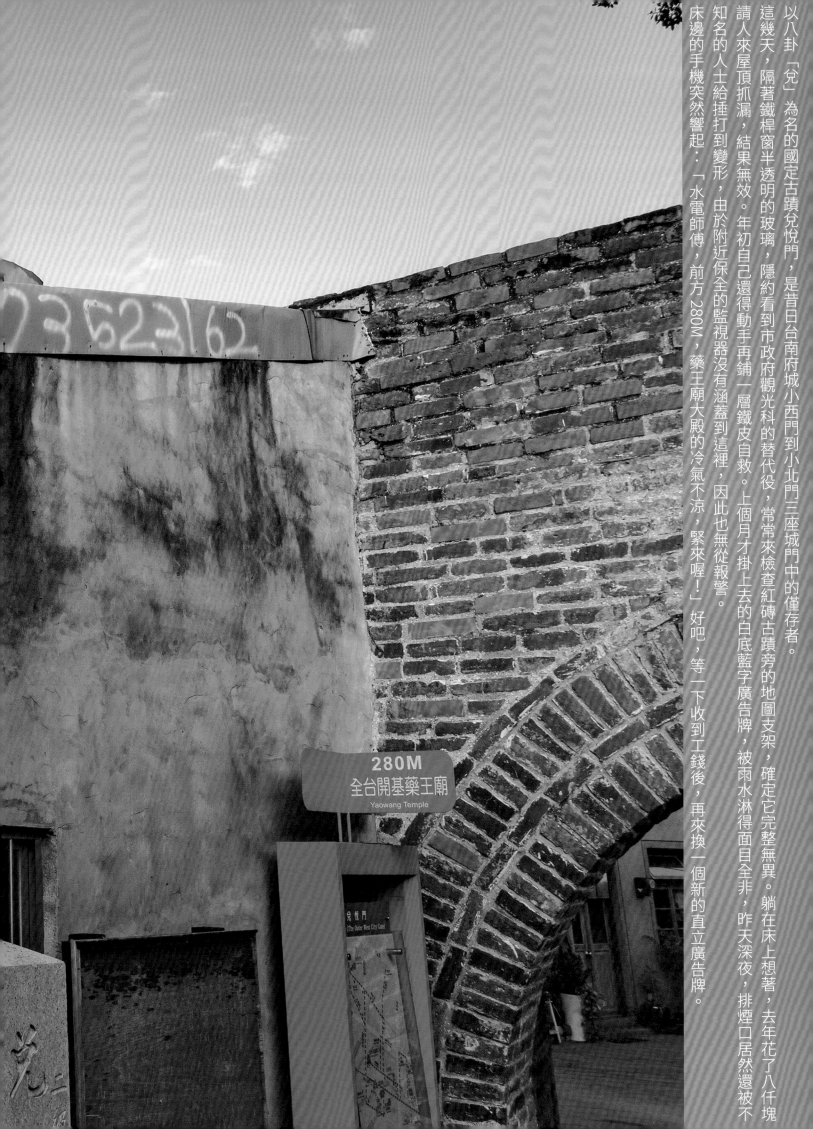

以八卦「兌」為名的國定古蹟兌悅門，是昔日台南府城小西門到小北門三座城門中的僅存者。

這幾天，隔著鐵桿窗半透明的玻璃，隱約看到市政府觀光科的替代役，常常來檢查紅磚古蹟旁的地圖支架，確定它完整無異。躺在床上想著，去年花了八仟塊請人來屋頂抓漏，結果無效。年初自己還得動手再鋪一層鐵皮自救。上個月才掛上去的白底藍字廣告牌，被雨水淋得面目全非，昨天深夜，排煙口居然還被不知名的人士給捶打到變形，由於附近保全的監視器沒有涵蓋到這裡，因此也無從報警。

床邊的手機突然響起：「水電師傅，前方280M，藥王廟大殿的冷氣不涼，緊來喔！」好吧，等一下收到工錢後，再來換一個新的直立廣告牌。

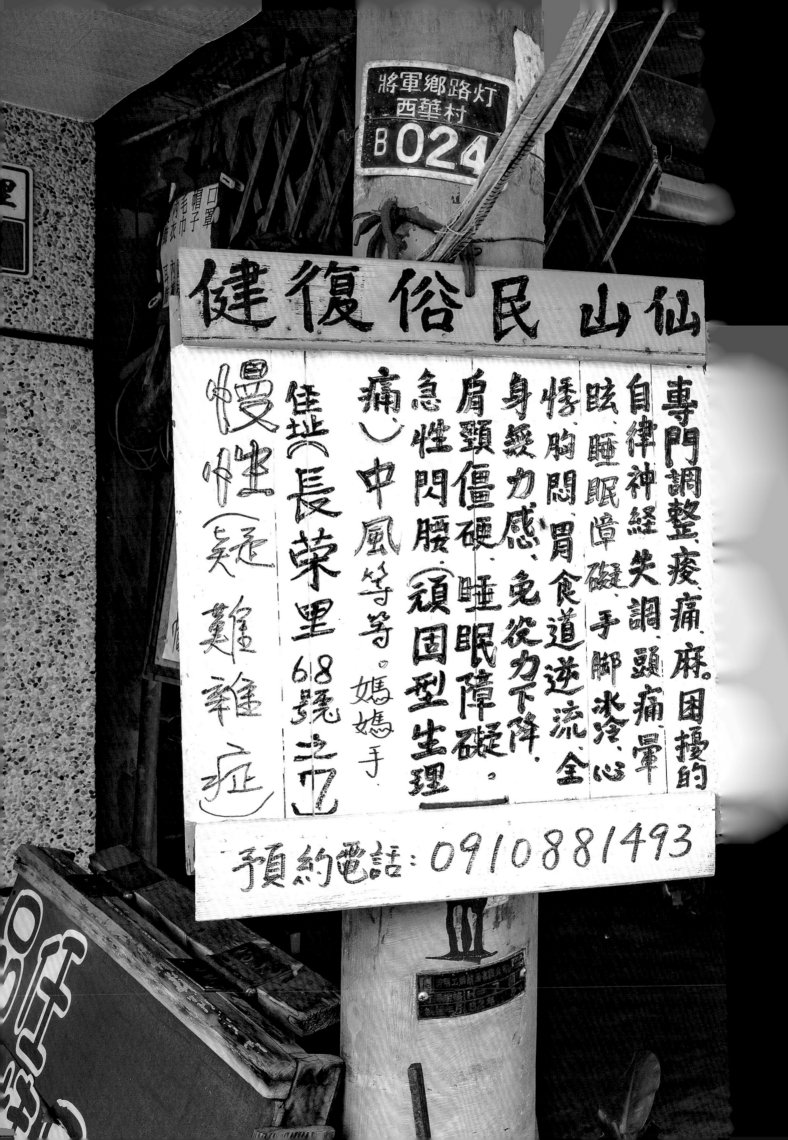

將軍鄉路灯
西華村
B024

仙山 民俗 復健

專門調整痠痛、麻。困擾的
自律神經失調、頭痛暈眩、睡眠障礙、手腳冰冷、心
悸、胸悶、胃食道逆流、全
身乏力感、免疫力下降。
肩頸僵硬、睡眠障礙。
急性閃腰（頑固型生理
痛）中風等等。媽媽手。
佳里（長榮里68號之7）

慢性（疑難雜症）

預約電話：0910881493

台南醫學院戶外教學，早上先去北門濱海將軍鄉，參觀黃清舞醫生的故居——方圓美術館。午餐自理時，一群準醫生手拿著三角飯糰站在騎樓下，研討鐵灰將

軍路燈、紅繩吊掛看板上的醫學密碼：

仙（角）（下）山民（間）俗（世）復健（之家），慢性疑難雜症（住家客廳看診）

晨診：（老舊床板）調整酸痛、麻

早診：（男女分手）睡眠障礙（鰥寡孤寂）手腳冰冷，心悸胸悶，頭痛暈眩

午休：（醫生自己）全身無力

午診：（喝咖啡配甜食）胃食道逆流

晚診：（電玩手）肩頸僵硬，（臉書、網紅拇指按讚）媽媽手，自律神經失調

午夜診：（怪異愛姿）急性閃腰、免疫力下降

電話密診：頑固型生理痛

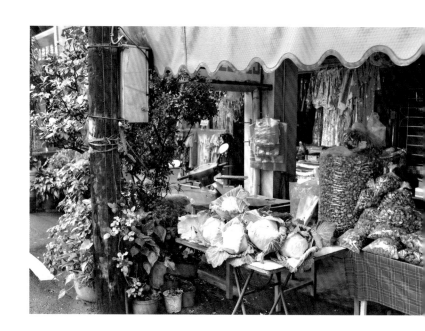

To complete my painting, I stayed up for three days and two nights but overslept on the morning of art school's Final Group Review. Upon nightfall, the school secretary texted me that the entire faculty h decided to fail me. I was lost. I had completed my work and did not mean to be absent from the revie why did those teachers treat me so meanly? I'd won many art awards(Although many award-winni projects were actually co-created by some of these teachers, I never divulged a word). Alright, then, I had enough of those hypocritical art professors who talked about theory all the time and never creat anything. My tolerance had been pushed beyond its limits already. Perhaps it was the will of god, I w leave this private vocational school in the remote south. The end of this lousy institute will happen soor or later anyway. I am leaving now and I will start looking for the next school. These thoughts relieved my anger, and I began to pack decided to drive back home to Hsinchuang. My parents would take me in.

Hey, it struck me that the lease of my studio in Jushan wasn't due, so I sat down, turned on my laptop and posted on Facebook to try luck, "Studio with artistic ambiance for rent. Monthly rent is lower than two thousand (utilities included). Shower but no toilet(Find a pla to release around the yellow wall and the green bush. Very convenient because you don't need to flush.) Interested tenants don't ne appointments, just find the place with the address provided and check it out (The power switch is on the left wall in front of the staircas Do not flip over or throw away the green canvas. Please make sure to switch the lights off when leaving (Electric bill is unusually high summer). Many thanks.

In the beginning of August, I took a long leave from the TV station I worked for. Taking off the suit I wo for work, I prepared to attend the indigenous Tayal Maho(Ancestral Worship) in my hometown Sqoya Community. I made a phone call to Lawa, inviting her to travel back together. Lawa grew up with me a was working in the building next to my work. I had driven my grandpa Walis' antique car to a garage a checkup the day before yesterday, in case any problems happened during the ride. Before taking off bought three rice balls from a convenient store, then drove along the Daan Forest Park and the side ga of the National Taiwan University, then got on the No. 5 Expressway and Snow Mountain Tunnel to Yil (Provincial Highway 7), Qilan (Provincial Highway 7-A), Siyuan Pass and Wuling Farm. , We arrived the mountain peak where the tribal community was(a 122KM ride) at night. Lawa had been asleep the whole ride, now she woke up a rolled down the window, waving with her red high-heels excitedly. She yelled toward the track and field surrounded by the ranges of Nan Mountain and Snow Mountain. Outside the window was a parking sign tied to an electric pole. It was tilted because of an accident with a c full of tourists about the time of last year's Maho. The statue of a tribal man standing on the rail had escaped the car accident, thanks to t blessing of the ancestral spirits, but the lamppost had not worked since then.

Sitting at the front seat of Dad's hearse that was driven slowly along the Chungtan Highway toward the crematorium, my eyes were blurred by tears. Passing a large sign by the road that read "Meals", memories surfaced.

Dad, in my first year of junior high, one night when you did not allow me to have bubble milk tea with dinner I refused to talk to you for two days. And the first time I went home for vacation from the military training camp for college freshmen, you were so happy, you took all of us to Shenkeng for stinky tofu despite the scorching sun. There were four or five Chinese mainlanders sharing the shabby brown table with us, they were so loud and you did not say a word throughout the meal.

Dad, I did not dare to tell you that my wife Ju-Yi had moved out last year, after a fight with me. Now I have to cook for my two children and discovered some facts, like cafeterias usually only provide lunch and dinner, not breakfast, and "stew" means slow cooking by soy sauce, and many restaurants only provide rice, not the stir-fried noodles my son likes. The night before last night, my fifth-grade daughter sentimentally commented on the mesona grass juice she was drinking with furrowed brow, "A little bit bitter, like broken love" And this afternoon, the female representative of our neighborhood gave me a bottle of mesona grass juice and told me, "This drink is great any time, not just when you lose your temper."

The hearse moved 100M forward, as it passed the front of the restaurant indicated by the large sign, I turned my head to the back and asked, "Dad, are you hungry?"

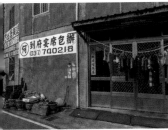

In the morning I backed up my car, loaded with the groceries I had bought, to the kitchen door, then with my little granddaughter, I lowered my head and walked under the laundry drying in the sun.. We were going to our English class. I sat at the back of the classroom and memorized vocabulary word-by-word. Hopefully one day I will be able to write down my menu in English. Right after noon, my work was to answer phone calls in the lobby. Requests of my service include freestyle menus for family gatherings, corporation banquets, special ordered feasts. . . The dishes I provided for the god's birthday celebration organized by the neighborhood chief the day before yesterday were Rice Cake With Grilled Eel, Garlic Shrimp With Thick Rice Noodle, and a variety of seafood for the soup called Buddha Jumping Over the Wall. Yesterday my fourth brother's sworn brother made offerings to the gods with Auspicious Platter, Fortunate Sweet And Sour Fish, Spring Greeting Bok Choy Mushroom Chicken. Next Saturday for the wedding of the police station chief's child I will prepare Blessing Veggies Braised With Chicken Kidneys, Lucky Bamboo Fungus Fried With Pig Tripe, Steamed Fresh Abalone With Mashed Garlic. At the end of this month, for my aunt's funeral, I plan to cook Nagaimo Swamp Eel Soup, Moonbean Noodle Boiled With Crabs, and Wolfberries Nagaimo Chicken Kidney Soup.

Luncheon, noontime feast, early afternoon banquet.... Phone calls keep coming, I write notes unceasingly and my mind stays so busy… Alas, nowadays young people have no idea about the old saying that doctors hate to treat coughs because there are too many possible causes of coughing, and chefs hate lunches because there is too little time to prepare.

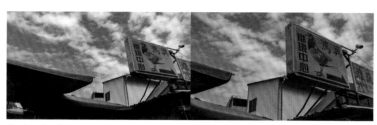

A couple of old people traveled to Europe, they enjoyed feeding pigeon on the plaza to their delight. After the trip, they greatly missed the fun they had. The following spring, they traveled to Tainan and saw a sign "Pigeon Rings", so they entered the store to inquire about raising pigeons. The young man in the store smiled, "Uncle, aunty, are you interested in raising racing pigeons? Put the rings on the baby pigeons right after they break their shells. Do not mate them too early. The rings are like their ID Card, they can't be reissued if you miss the timing of adding them. And without ID Cards they are not eligible for races. The outer diameter of a ring is no bigger than 7.5mm, the inside layer must be maintained clean and cannot be deformed. Be particularly careful to keep them free from dirt or feces, otherwise the birds might get infected. Breeding and raising racing pigeons is a highly professional business, you must make sure they are in a good environment, get them vaccinated accordingly, and provide them with enough nutrition. Training them for too long will hurt them, and also, after training they might follow other pigeons and never return. "

"Dad, wait for a moment. How about we don't eat eel noodles today, let's go to the top floor of the department store to have salmis pigeonneau in the only passable French restaurant in Tainan?"

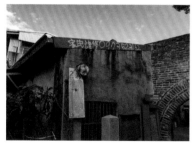

Duiyue Gate, a designated national historical site with the name "dui" from the eight trigram, is the one preserved gate of the three gates in the area from the Little West Gate to the Little North Gate in ancient Tainan City.

These days, through the translucent window glass, I always see the young man serving his military duty in the Tourism Division of the city government coming to check if the framed map by the red-bricked historic gate is not skewed or damaged. Lying in bed, I recall that last year I spent eight grand to have the leaky roof fixed, but it never worked. In the beginning of this year I added a layer of iron sheet to help the situation. The new sign with blue characters on a white panel I put up last month was completely ruined by the rain, and last night the smoke exhaust pipe from the kitchen was destroyed by unknown vandals. Unfortunately the CCTV of the neighborhood doesn't cover this area, so it's probably useless to report the incident to law enforcement.

Suddenly my cell phone beside my bed rang, "Mr. Electrician, 280M from you, the air conditioner in the major hall of the Temple of Medicine God is not working. Come over as soon as possible."

"OK." After receiving the pay from repairing the air conditioner, I will paint another advertisement.

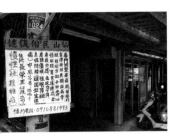

During an outing to the Tainan College of Medicine, the group went to Chiangchun Village along the coast of Beimen in the morning to visit the past residence of Dr. Huang Ching-Wu, which had been transformed into the Fang-Yuan Art Museum. During lunch, the group of doctors-to-be stood under a corridor with onigiri rice balls in their hands, discussing the secret medical codes hung on an iron-gray lamppost by a red thread.

Old Fairy Folk Rehabilitation, treating complex chronic diseases(treatment conducted in patient's living room)

Morning Clinic: Relieving pain and numbness(caused by decrepit beds)

Forenoon Clinic: Sleep Disorders (caused by broken love), Cold Limbs (caused by sleeping single), palpitations or chest tightness, headache or dizziness

Lunch Break: Powerless (the doctor himself)

Afternoon Clinic: Gastroesophageal Reflux Disease (causing by eating sweets with coffee)

Evening Clinic: Rigid Neck and Shoulders (causing by online game playing), Carpal Tunnel Syndrome (causing by clicking "like" on Facebook), Dysautonomia

Late Night Clinic: Lower Back Sprain (causing by unusual lovemaking positions), Declining Immunity

Private Telephone Consulting: Menstrual Cramps

In the brilliant sunlight, blessings fall from the sky. Our wonderfully connected destiny is endorsed by heaven and earth.

Today, the blue on the left and the red on the right are bonded, like red flowers held by green leaves. Bow to each other and be grateful to heaven and earth.

Overlooking the leaky eaves on the roof, we grow old together. The betel nut store in the alley provides neighbors with "buy one get three" deals and free delivery. The telephone rings, no phone call is unanswered.

A sign says at theentrance of Lane 158 by the road,, "Smokeless and odorless charcoal. Favored by BBQ stores. Only 4 boxes left, get them now!" (But looking around, no one was in charge.)

More than ten years ago, I was sent to the Kingdom of Eswatini in Africa during my military service as a member of the Taiwan Technical Mission in Eswatini. I learned how to produce charcoal from the local people, and married Nana, the daughter of the Province Governor. I founded this store after I came back to Taiwan, and delivered goods in person when I had time.I also teach new drivers how to drive. Instead of having students come, I went to them. And in order to maintain high ethical standards, I set up two es. One is I will film the classes, another is once the class is over, I won't spend my private time teaching. Male students usually will take sses by themselves, female students can have their accompanying classmates in the rear seat, I won't charge more.

been standing in the corridor for a while when a young girl with pink shorts walked past then returned to ask in a loud voice, "Cute Boss, e Moon Festival has passed, do you offer a discount for the BBQ charcoal? And, if I buy charcoal, do you offer a discount for the driving sons?"

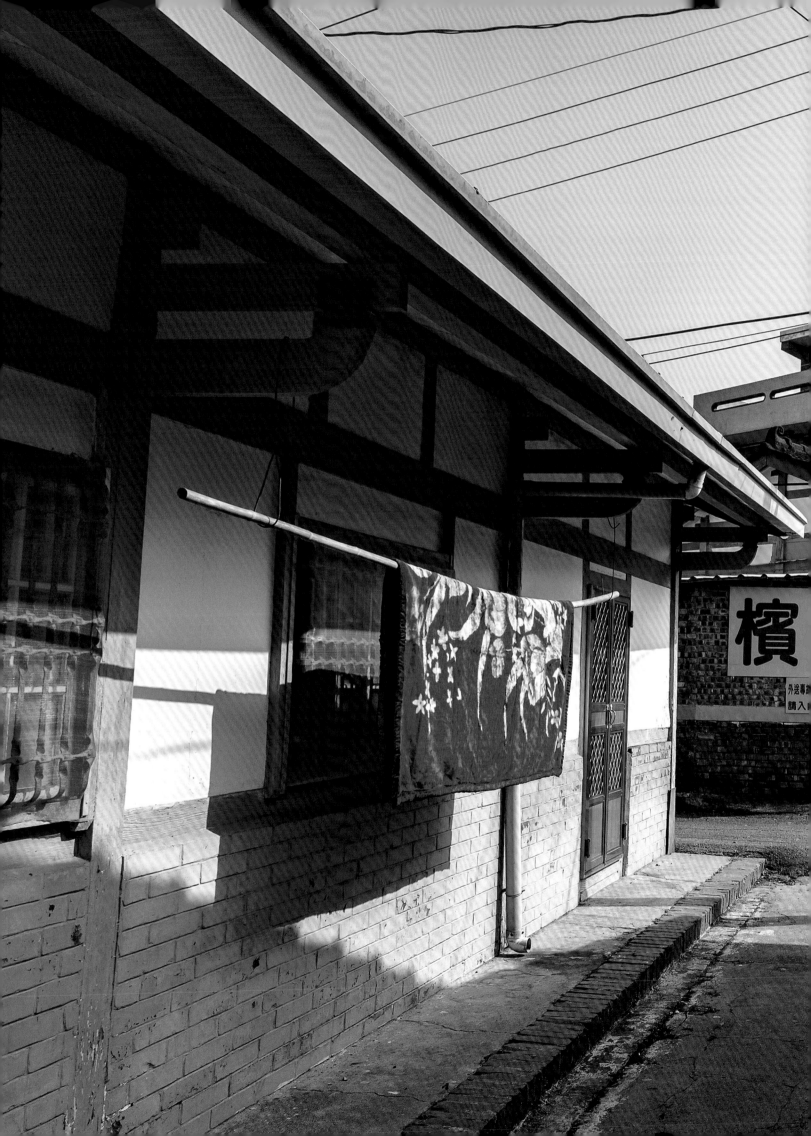

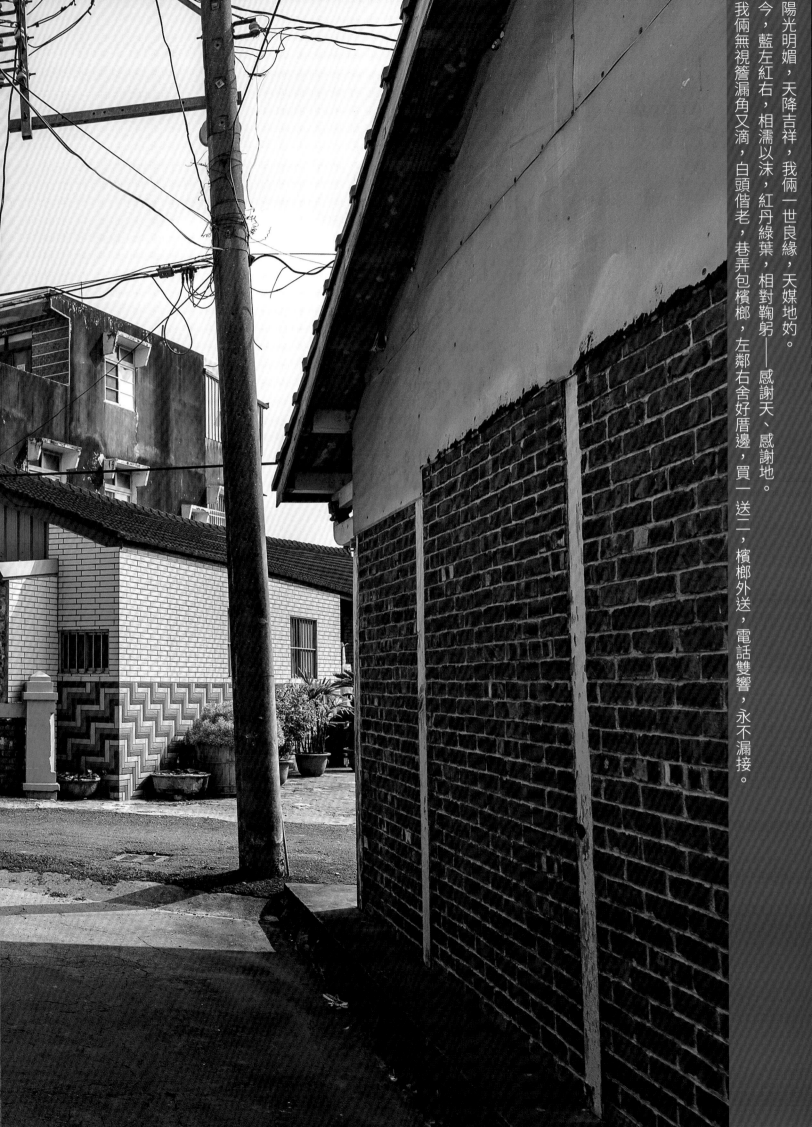

陽光明媚，天降吉祥，我倆一世良緣，天媒地灼。

今，藍左紅右，相濡以沫，紅丹綠葉，相對鞠躬——感謝天、感謝地。

我倆無視簷漏角又滴，白頭偕老，巷弄包檳榔，左鄰右舍好厝邊，買一送二，檳榔外送，電話雙響，永不漏接。

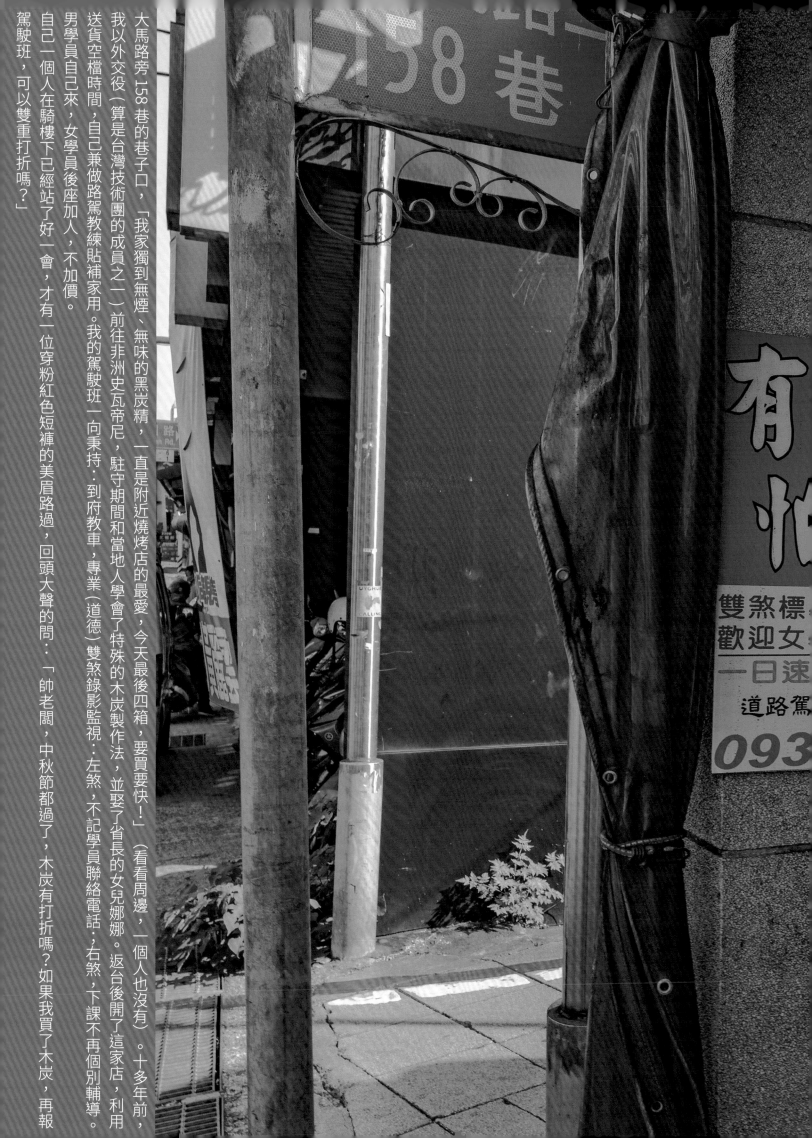

大馬路旁158巷的巷子口，「我家獨到無煙、無味的黑炭精，一直是附近燒烤店的最愛，今天最後四箱，要買要快！」（看看周邊，一個人也沒有）。十多年前，

我以外交役（算是台灣技術團的成員之一）前往非洲史瓦帝尼，駐守期間和當地人學會了特殊的木炭製作法，並娶了省長的女兒娜娜。返台後開了這家店，利用

送貨空檔時間，自己兼做路駕教練貼補家用。我的駕駛班一向秉持：到府教車，專業（道德）雙煞錄影監視。左煞，不記學員聯絡電話；右煞，下課不再個別輔導。

男學員自己來，女學員後座加人，不加價。

自己一個人在騎樓下已經站了好一會，才有一位穿粉紅色短褲的美眉路過，回頭大聲的問：「帥老闆，中秋節都過了，木炭有打折嗎？如果我買了木炭，再報

駕駛班，可以雙重打折嗎？」

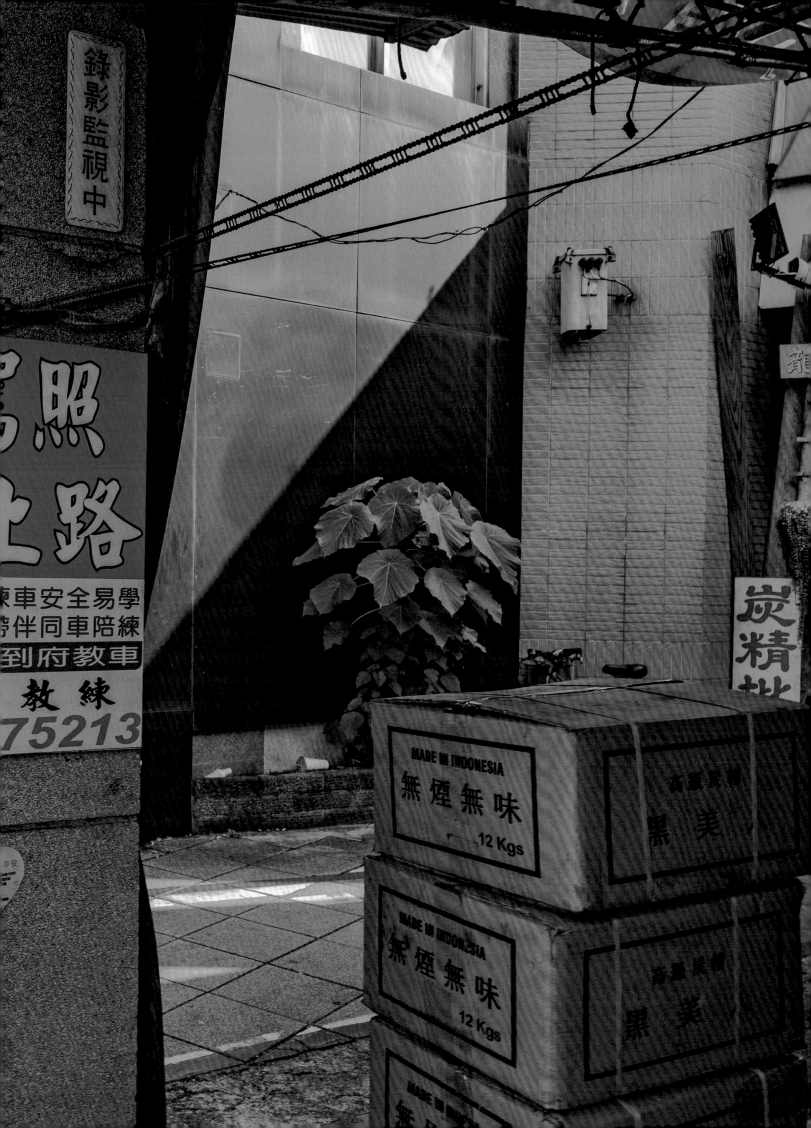

農曆三月媽祖繞境，公獅、母獅豎耳，林春娘祈雨。貞孝牌坊，坊柱楹聯，牌頂聖旨，四柱、三間，矮欄環繞。

鎮瀾宮前，紅磚人行道，一塵不染，紅花艷艷；

繞過石獅，

跳過上海肉包，直走鎮瀾宮正門，餅店貨架上，外人嚐鮮：鳳梨酥、綠豆皇、小酥餅，在地人的最愛。

芝樺，談了七八年，我倆終於同意揮別婚姻的圍籬，慶幸！

代書說：離婚——須年滿 20 歲以上，法律認定有完全行為能力；須親自見證（或聽聞後確認意圖與意願）；（當事者二位，充分了解動機與決心的證人二位）在協議書上簽名。過程，代書將會免費的錄音、錄影，避免往後衍生爭議。

芝樺，現在台灣同性婚姻已經合法，國雄與我，決定共度餘生。對了！妳爸爸送我們的結婚禮物——黑色轎車，直接歸你。車子的雨刷已經非常舊了，開車前記得先去保養站換一把新的。

137

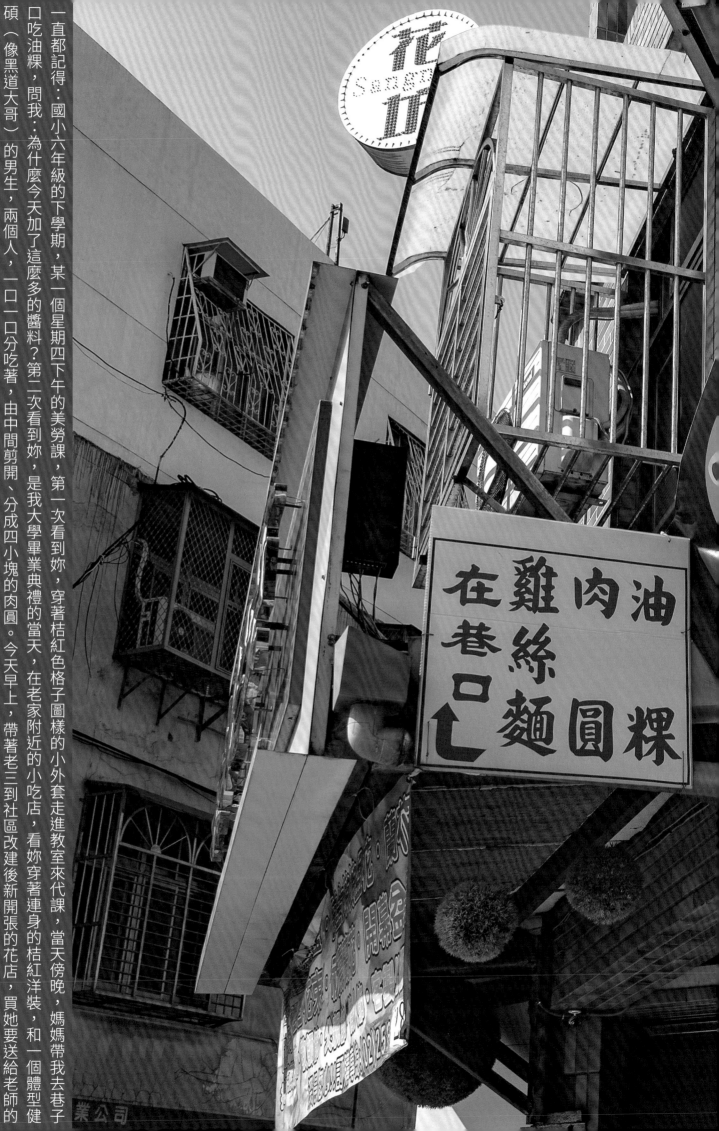

一直都記得：國小六年級的下學期，某一個星期四下午的美勞課，第一次看到妳，穿著桔紅色格子圖樣的小外套走進教室來代課，當天傍晚，媽媽帶我去巷子

口吃油粿，問我：為什麼今天加了這麼多的醬料？第二次看到妳，是我大學畢業典禮的當天，在老家附近的小吃店，看妳穿著連身的桔紅洋裝，和一個體型健

碩（像黑道大哥）的男生，兩個人，一口一口分吃著，由中間剪開、分成四小塊的肉圓。今天早上，帶著老三到社區改建後新開張的花店，買她要送給老師的

畢業禮物，第三次看到妳，單手扶著嬰兒車，躺在裡面的小孩，胸前綁著桔紅色的圍兜兜，一旁，頂著刺蝟頭的小男生，面無表情的將一絲一絲乾的雞絲麵塞進

嘴巴裡。

微微抬頭看一下上天，左邊，直走到底死巷，右邊，鐵欄杆緊緊圍住，桔紅色的情愫在分岔路口——飄散。

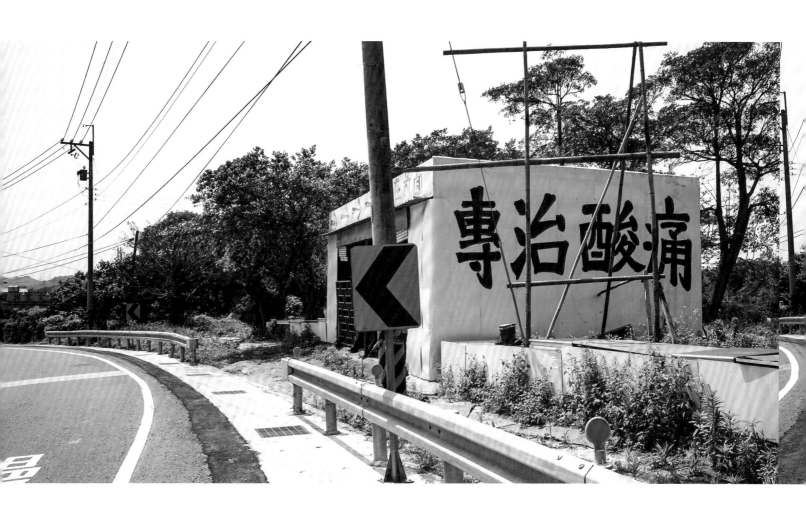

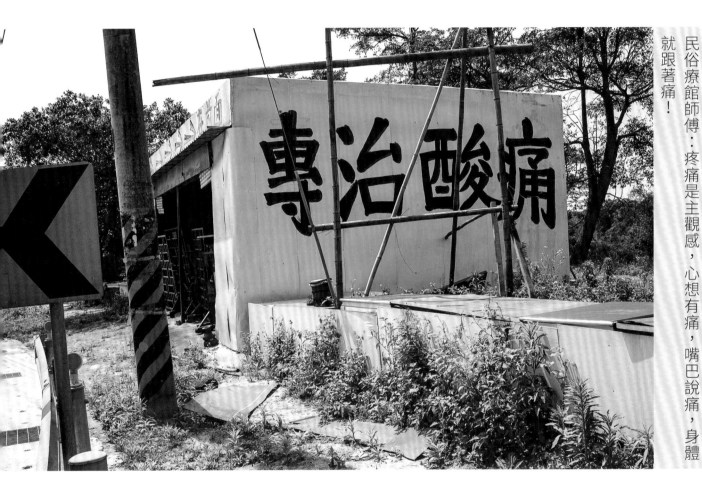

這裡痛！那裡痛！頸、肩、手、腳、足——無處不痛，痛到真想死！

疼痛科，先求不痛再根治。醫師：緩解疼痛，復健，訓練肌肉，疼痛解決。

民俗療館師傅：疼痛是主觀感，心想有痛，嘴巴說痛，身體就跟著痛！

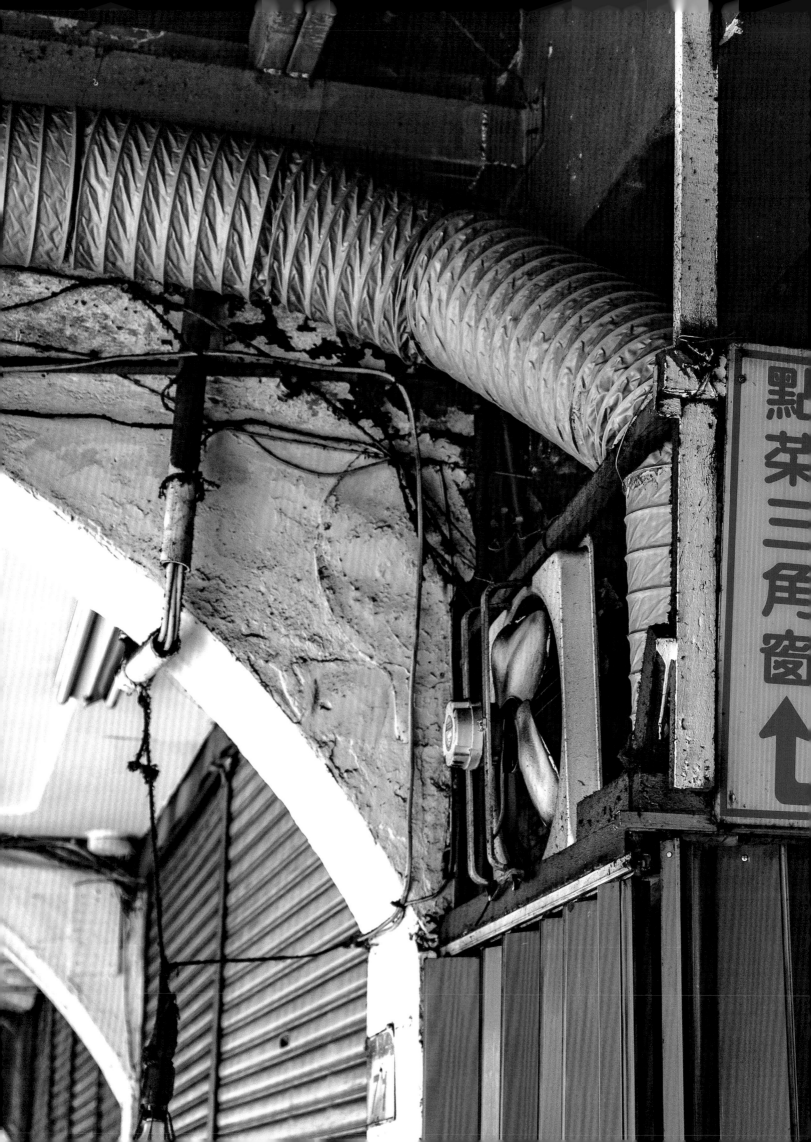

台北後火車站，生活百貨圈的老闆，最了解全球化斷鏈的結果。

青菜豆腐／蛋花湯￥30（青菜加量、豆腐加大、蛋兩顆）。

蚵仔酥／鹹酥蝦￥120（自家後院新鮮九層塔，進口胡椒鹽）。

炒螺肉／五花燒肉￥120（小朋友以前寫錯價，不好意思）。

炒牛肉／羊肉￥120（水耕空心菜，吃到賺到）。

乾煎虱目魚￥120（每天從台南搭高鐵來，加長煎魚時間）。

客家小炒￥120（南北韓情勢緊張，魷魚進口有限）。

回鍋肉￥100（高級蒜苗，真川菜）。

吳郭魚？？140（大量的魚塭池塘，塘填土蓋大樓）。

糖醋排骨-停止供應（客人要求不油炸、不加糖、醋要少，老闆娘自尊受損）。

咦？「招牌飯」為什麼被蓋掉了？老主顧，左轉後朝北、過水電行，問半個身體躲在三角窗後面，從早到晚頻頻和路人點頭微笑的美珠。

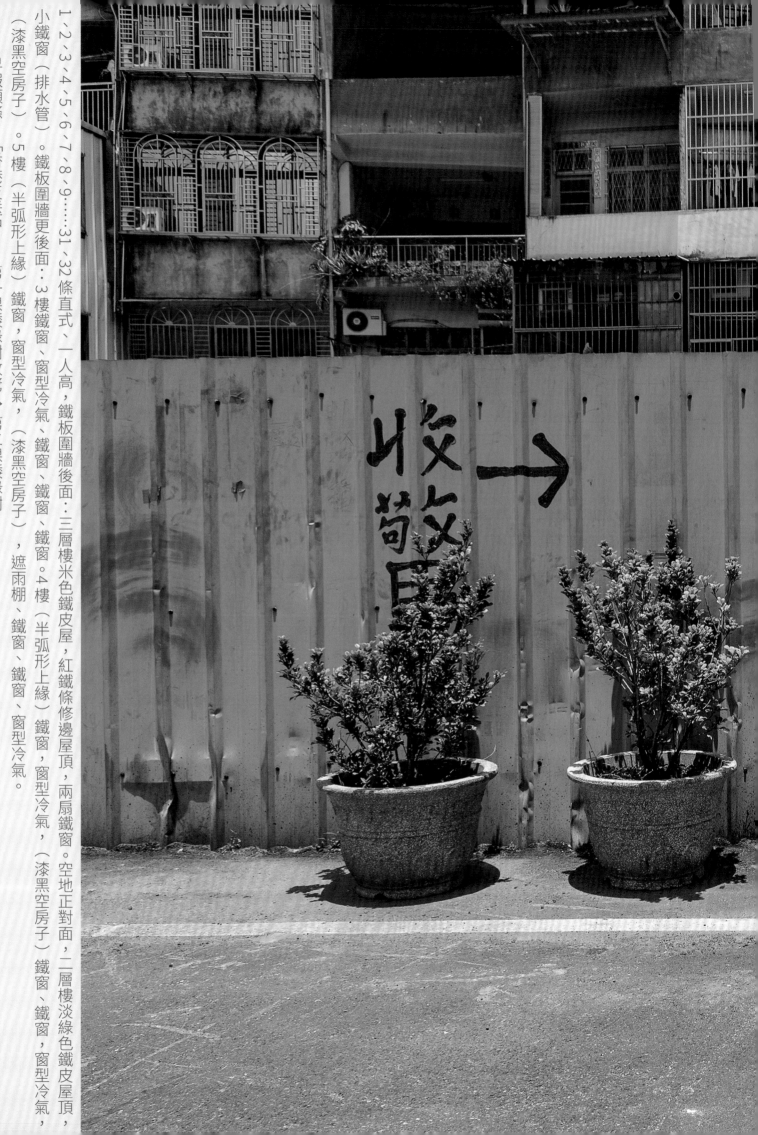

1、2、3、4、5、6、7、8、9……31、32條直式、一人高、鐵板圍牆後面…三層樓米色鐵皮屋，紅鐵條修邊屋頂，兩扇鐵窗。空地正對面，二層樓淡綠色鐵皮屋頂，小鐵窗（排水管）。鐵板圍牆更後面…3樓鐵窗、窗型冷氣、鐵窗、鐵窗、鐵窗。4樓（半弧形上緣）鐵窗，窗型冷氣，（漆黑空房子）。5樓（半弧形上緣）鐵窗，窗型冷氣，（漆黑空房子），遮雨棚、鐵窗、鐵窗、窗型冷氣。

早報頭條…「香港反送中」，第一棵矮綠樹收驚 → 第二棵矮綠樹……

晚報頭條…「香港實施國安法」，第三棵矮綠樹收驚 → 第四棵矮綠樹收驚 → ……

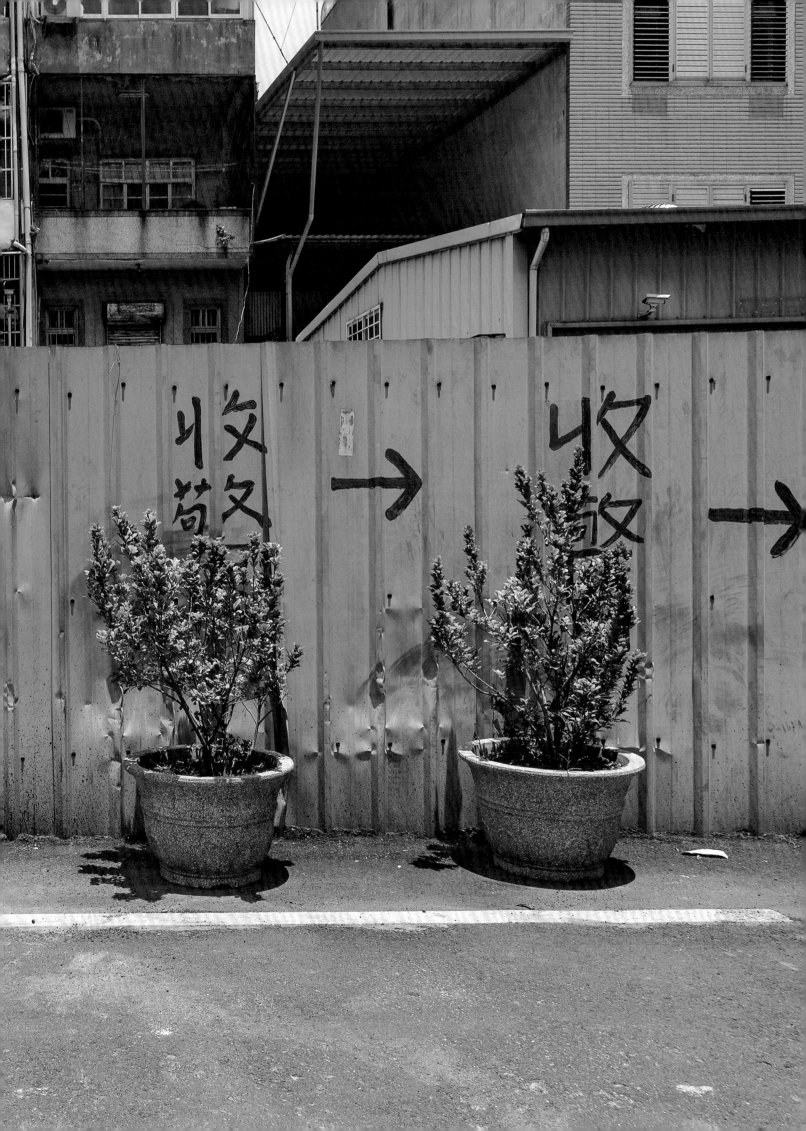

Lunar March is when the pilgrimage procession of Goddess Matzu takes place every year, male a
female lions point their ears, and Lady Chun-Nien prays for rain. The couplet carved on the columns
Lady Chun-Nien's memorial gate was endowed by the royal court. The three-layered space is framed
four columns and low rails.

In front of the temple, the pedestrian walk paved by red tiles is cleaned thoroughly, bright red flowe
decorate it.

Passing the stone lions, skipping the Shanghai bun store, toward the front of the temple, the bake
displays their products for visitors to taste: pineapple cakes, mung bean pastries, flaky biscuits. They a
loved by locals.

Chi-Hua, fortunately, after more than seven years, we both finally agr
to break away from the shackles of marriage. The notary told us that
divorce, both husband and wife must be over twenty-years-old in sou
mind, and must be present for the process(or whose will to divor
is confirmed). The four people(divorcing husband and wife, and tw
witnesses) shall sign on the divorce settlement. The notary will film t
process, free of charge, in case a dispute occurs in the future.

Chi-Hua, same sex marriage is legalized in Taiwan now, Kuo-Hsiung and I have decided to spend the rest of our lives together. The bla
sedan car your father gave us as a wedding present is yours. The windshield wipers are quite worn out, and before you use it, bring it to
mechanic for a checkup.

I always remember that during the last semester of my elementary school days, one Thursday afternoo
I saw you for the first time in our art class. You entered our classroom in an orange checkered jacke
you were our substitute art teacher. That evening when my mother took me to eat oily rice cake, s
asked why I added so much orange colored sauce. The second time I saw you was on the day of n
college graduation ceremony. In the eatery near my home, you were in an orange dress and dined with
stout man(a gangster-like person). You two were sharing a meatball cut into four pieces and taking tur
sending the pieces into your mouths. Not until this morning when I took my little daughter to the flow
store, after the town's redevelopment was completed, to find a present for her teacher, I saw you for the third time. You grasped a ba
stroller with your hand, and the baby in it was wearing an orange bib. Beside the stroller, an expressionless boy with spiky hair was putti
dried vermicelli into his own mouth.

I lifted my head slightly to see the sky. On the left was a straight dead end alley, on the right was a space strictly blocked by a wire fenc
Orange sentiment wafted at the crossroad.

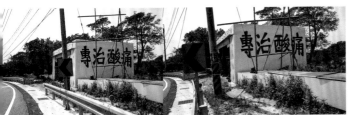

Pain here! Pain there!

Neck, shoulders, arms, legs, feet—pain is everywhere, you feel you'd rather die!

The treatment is to relieve the pain first, before getting rid of the causes of pain.

Doctor relieves the patient's pain with medication, then starts rehab and trains muscles to solve the pain.

Folk healer asserts that pain is the patient's subjective feeling. When one thinks it hurts, and says it hurts, the body begins to be hurt.

At the back of the Taipei Railway Station, store owners there know best about the consequences of global supply chain disruption.

Soup of Green vegetable & Tofu & Egg ~~10~~ 30 (more veggie, more tofu, two eggs)

Deep Fried Oysters/Deep Fried Peppered Shrimps ~~100~~ 120 (home-grown basil, imported pepper)

Fried Snails/Braised Pork Belly ~~100~~ 120 (apologies for the wrong price labeled by child)

Fried Sliced Beef/Fried Sliced Lamb ~~100~~ 120 (fried with water spinach, very good deal)

Dry-Fried Milkfish ~~100~~ 120 (delivered from Tainan daily via high speed railway; cooked with extra time)

Hakka Stir-Fry ~~100~~ 120 (limited imported squids due to the soaring tension between North and South Koreas)

Twice Cooked Pork ~~80~~ 100 (high-end garlic sprouts, down-to-earth Sichuan flavors)

Tilapia~~??~~ 140 (their fishponds have been filled for highrise buildings)

~~Sweet and Sour Ribs Service~~ Stopped (restaurant proprietress felt indignant about being asked not to deep fry ribs, not to add sugar, and less vinegar)

Why? Why are the words ~~Signature Meal~~ crossed out? An old customer turns left and walks past a plumbing business to the corner window to inquire of Mei-Ju, who was half hidden behind the window, but showed her smile to passersby from morning to night.

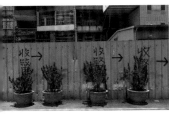

1, 2, 3, 4, 5, 6, 7, 8, 9 … 31, 32 vertical lines, a man's height, behind it is a three-story pale white iron house. Its roof is fixed by red iron rods, its two windows were also iron. Opposite the empty site is a two-story building with a light green iron roof and small iron windows(framed with water pipes). Further behind the iron fence are buildings with iron windows on the third floor and air-conditioners on iron windows. Iron windows with air-conditioners are also seen on the fourth floor(curved). Even the empty units(no lights) with awnings have iron windows. Iron windows and air-conditioners.

Headline of the morning newspaper: Anti-Extradition Protests in Hong Kong

The first potted plant exorcism → The second potted plant…

Headline of the evening newspaper: National Security Law Implemented In Hong Kong

The third potted plant exorcism → The fourth potted plant exorcism → …

147

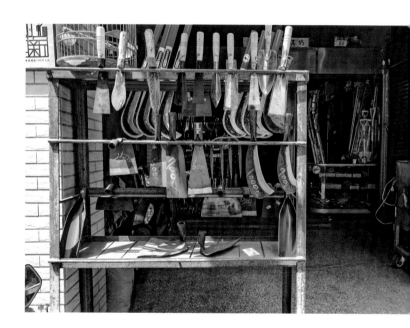

Yu is currently an adjunct professor of visual art at National Chengchi University in Taipei, Taiwan. His books include:

KED : SPEECHLESS (2020)
scendent Images, The Second Death (2019)
cated and Documentary Photography (2017)
Ba Photo Album (2015)
Words Around Us: Seeing Without Understanding (2014)
Latent and the Visible (2012)
c Art in Taiwan: Landmarks (2011)
s of Fine Art Photography (2003)
Puppet Bridegroom (2002)
een Real and Unreal: Reading into Taiwan, Part One (2001)
History of Surrealism In Photography and Its Applications (1995)
Yu Photographic Constructions (1990)

u has exhibited his work internationally in Paris, Berlin, Yokohama, Seoul, Beijing, Shanghai, Philadelphia, New York, and Taiwan. He
and works in the United States and Taiwan.

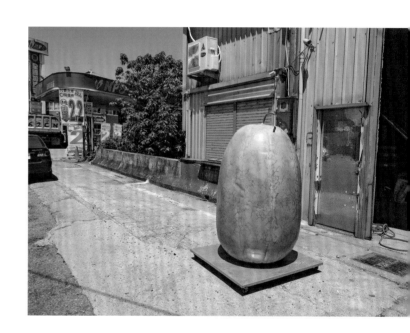

寬 1956 年生，在大專院校從事影像傳播與美學教育逾 30 年，

前是政治大學傳播學院專任教授、特聘教授 (2010-12)；

後來回美國、台灣從事創作。

政治大學傳播學院兼任教授，國立台灣美術館第十七屆典藏審議委員

著作：

罩風景》、《超越影像「此曾在」的二次死亡》、《「編導式攝影」中的記錄思維》、《五九老爸的相簿》、

活 · 臺詞》，我的「限制級」照片、《游潛兼行露——「攝影鏡像」的內觀哲理與並置藝術》、

灣公共藝術——地標篇》、《手框景 · 機傳情》——政大手機書、《美術攝影論思》、《台灣新郎》

假之間》、《論超現實攝影》、《游本寬影像構成》。

招 · 術　Welcome: The Art of Invitation

國家圖書館出版品 | CIP | 預行編目資料

ISBN 978-957-43-9457-9(精裝)
1. 攝影集
958.33　　110017710

初版　臺北市　游本寬著　2021.11
152 面；23 x 30 公分

出版：游本寬 /Ben Yu
地址：台北市大安區建國南路二段 308 巷 12 號 7 樓
信箱：benyu527@gmail.com
網址：benyuphotoarts.tw

印刷：佳信印刷有限公司
地址：新北市中和區橋安街 19 號 3 樓
電話：(886)02-22438660
信箱：chiasins@ms37.hinet.net

代理經銷：田園城市文化事業有限公司　　地址：台北市中山區中山北路二段 72 巷 6 號
Facebook：田園城市生活風格書店　　電話：886-2-2531-9081　　傳真 886-2-2531-9085
讀者服務信箱：gardenct@ms14.hinet.net

2021 年 11 月　定價：新台幣 1,000 元　版權所有 | 翻印必究

Preface translation by: Lauren Sung, Sean Yu
Contributing Editor : Karen Serago
Stories translated by C.J. Andrson-Wu, Steven M. Anderson

benyuphotoarts.tw